IMAGES
of America

HOLLAND POINT

2/17

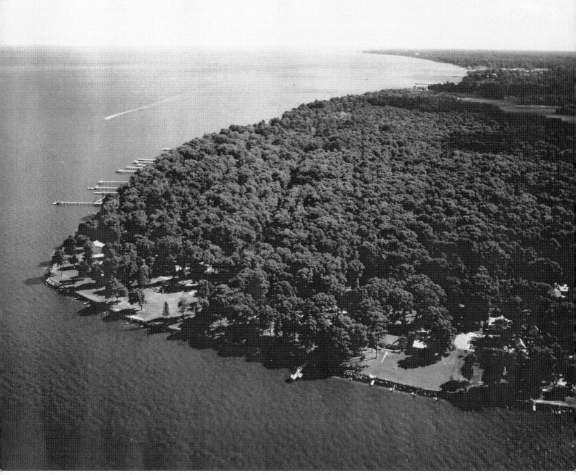

In 1985, David Wallace Aerial Photography created this picture of Holland Point. The jutting, extended point of land that Capt. John Smith passed in 1608 had long ago vanished because of storms, erosion, and the grinding of the tides, leaving a much softened but still distinctive point of land. (KKDW and RB.)

ON THE COVER: Neighbors gather on the beach in 1930 at the Parker family's long rowboat, typical of the period. Members of the Parker and Buckingham families are represented in this image taken at a carefree moment when the original beach was large enough for all kinds of boats and recreational activity. Three years later, a giant hurricane destroyed the beach. (JB.)

IMAGES
of America
HOLLAND POINT

Janet Bates, Joy Baker,
and Alice Birney for the
Holland Point Citizens Association

Janet Bates

Joy Baker

Alice Birney

ARCADIA
PUBLISHING

Published by Arcadia Publishing
Charleston SC, Chicago IL, Portsmouth NH, San Francisco CA

Printed in the United States of America

Library of Congress Catalog Card Number: 2007926278

For all general information contact Arcadia Publishing at:
Telephone 843-853-2070
Fax 843-853-0044
E-mail sales@arcadiapublishing.com
For customer service and orders:
Toll-Free 1-888-313-2665

Visit us on the Internet at www.arcadiapublishing.com

To all of the people of Holland Point, past, present, and future.

CONTENTS

ACKNOWLEDGMENTS

We thank our sponsor, the Holland Point Citizens Association, for its support of this publication. Particular thanks are due to past president Ed Conaway for negotiating the contract phase. Our Arcadia editor, Lauren Bobier, patiently guided us through the labyrinth of details leading from concept to realization. Additionally, we are grateful to Sheila Stout and David McKenna for research and editing and to Mary Jane Bolle and Adrian Birney for copy reading. Finally, this book could not exist without the many contributions of photographs and memories from past and present residents, their friends and relatives, and from a few archives. At the end of each caption in the book is an abbreviation indicating the source of the image, as keyed to the list below.

AB: Aubrey Bodine, © Jennifer Bodine
ALB: Alice Lotvin Birney
AP: Albert "Al" Patane
APP: Ann Parker Parks
BB: Betty Kennedy Burley
BC: John "Bus" Cannon
BD: Bolling DeSouza
BP: Beverly Bowen Page
BQ: Betty Quigley
CBP: Chesapeake Bay Program
CBRM: Chesapeake Beach Railway Museum
CW: Carol Wondrack Wyman
DM: David "Dave" McKenna
DT: Martha "Dolly" Thomas and
 Dolores Link
EC: Edmund "Ed" Conaway
HL: Helen Federline Lidie
HPCA: Holland Point Citizens Association
JB: Janet Buckingham Bates
JEB: Joyce "Joy" Ellen Baker
JF: Julie Buckingham Ford
JGB: Jack G. Bannister
JH: Judy Harger
JL: Jay Loveless
JM: Jean Bates Morris
JP: Jean Pulse
JTB: John T. Breslin
KD: Katherine Warman Day

KKDW: Kenneth King, © David Wallace
 Aerial Photography
KP: Klara "Sue" Penzes
KY: Kathleen "Kathy" Cheston Young
LB: Louise "Lisa" Pryor Baker
LOC: Library of Congress
LP: Linda Panzone
LS: Lyn Sutherland
MK: Michael Keane
MT: Miles Miller Taggert
NH: Norma Hald
NY: Nancy Bates Young
PH: Peter Hooper
PT: Patricia "Pat" Knowles Tait
PW: Penny Williams
RB: Ronald "Ron" Britner
RD: Rosemarie Patane Dupy
RH: Ruth Zimmerman Haigh
RM: Ruth Marx
RR: Rosalie Russell
SL: Suzanne Livingston
SLL: Suzanne L. Liggett
SP: Sue Power
SS: Sheila Stout
TH: Theresa "Terry" Haas
VC: Virginia Clark Casey
VW: Valery Watson
WS: Whitey Schmidt

INTRODUCTION

Holland Point is a less-than-two-mile residential community, but it has two names and two addresses. It was carved out of Holland Point Farm in 1922 and founded as North Beach Park before later taking back its historic name. Situated at the southeastern end of Anne Arundel County, its post office address is in adjoining Calvert County in the town of North Beach. The 1922 developer might be considered Holland Point's father, but its mother will always be the Chesapeake Bay. Her natural beauty and weather challenges have shaped the direction of the community for almost a century of modern settlement and for thousands of years before.

For the origin of the Chesapeake Bay basin, geologists say that the shifting tectonic plates and a pull-apart basin created the bowl for the largest estuary in the United States. Astronomers suggest a dramatic new theory: 35 million years ago, a giant space rock smashed into the coastal Atlantic and created the crater that would hold the bay; saltwater then infiltrated a jumble of smashed sedimentary rock. In both scenarios, by 9,000 BC, the bay began to take its familiar shape when melting glacial ice slowly filled the lower Susquehanna River Valley. Native tribes that had crossed to North America from Asia over the Siberian land bridge then began arriving. A 1977 archeological dig near Holland Point at a Rose Haven site unearthed native soapstone bowls, grooved axes, arrowheads, and simple pottery left from their summer visits between 400 and 900 AD. Later tribes grew crops and fished in *Chesepioc*, which meant both "Country of the Great Rivers" and "Great Shellfish Bay." Algonquin-speaking tribes used the waters for transport, harvested fish and shellfish, traded the area's resources, and were the first people to enjoy its natural beauty.

When the Renaissance inspired Europeans to explore a world no longer feared to be flat, they too discovered the beauty and wealth of this great bay and began to inhabit and exploit it. Italy's Giovanni da Verrazano sailed by the Chesapeake in 1524. Spain's governor of Florida, Pedro Menendez de Aviles, explored the bay in 1572. But it was Capt. John Smith and his crew of 14 in their small sloop who first mapped the bay for England. During their second exploratory voyage up from Jamestown in 1608, they rowed by the future Holland Point protruding from the western shore of Maryland while going north en route to explore the rivers. On their return trip southward, the crew entered Herring Bay and spent the night of June 15, 1608, on the beach just north of Holland Point.

Early Colonial settlements in this area took the form of scattered farmsteads, frontier outposts, and small port communities. Native Piscataway Algonquians befriended European settlers as allies against the Susquehanok Iroquois invading from the north. The Piscataway holy ground is a national park near modern Washington, D.C. Just south of Holland Point lived the Mattapanient natives.

In 1650, Lord Baltimore laid out Anne Arundel County down to Herring Creek, at the northern edge of Holland Point. An archeological dig in 2001 located the nearby remains of the *c.* 1690 mansion owned by Samuel Chew. Its high chimney was used as a navigation point for ships rounding a sand bar as they came into port at Herrington near current Fairhaven on Herring Bay.

Chew was one of Anne Arundel's founding fathers, owning thousands of acres of south county land. Francis Holland Sr. purchased some of this land around 1663, which included Bennet's Island. Part of this "Holland's Charge" subsequently was acquired by Sam Owings. By the late 19th century, over 300 acres of it were identified as Holland Point Farm, part of which, in a 1919 surveyor's map, was also called Bennet's Island. Attorney Gibbs Baker and associates bought that 1.2-mile-long farm in 1922, subdivided it into hundreds of prospective lots, and renamed it North Beach Park. That name is used throughout this book as synonymous with Holland Point.

Life in "the Park" started with the desire to escape the city in hot summer months and to have fun. Visitors first came out from the cities to the near western shore to play for the day at Chesapeake Beach amusement park in 1900 and, in a few years, to swim and stay at new hotels in North Beach. When North Beach Park was founded a mile up the unpaved road near Holland Point, another stretch of bay front opened out. There settlers swam, canoed, sailed, fished, hunted, partied, and valued the nature right near their own summer cottages. Later, motorboats towed water skiers across the bay, and still later, jet skiers appeared with their "rooster tails."

Creating housing has been a basic activity from first to last. Some settlers first purchased lots and put up tents. Early cottages were one story, with outhouses, wells, kerosene lamps, and wood stoves. Improvements came, including indoor plumbing, electric heat, water pumps, and septic fields. Building came to a standstill around 1990 for some 10 years because of the building moratorium by Anne Arundel County. Inadequate treatment of sewage prohibited building new homes. At the dawn of the 21st century, a new sewer system, shared with Rose Haven to the north, lifted the moratorium on building. Grand homes sprang up as empty lots filled and many residents expanded or replaced their cottages.

Storms and hurricanes have long harried these shores. The first one to cause a rude awakening after the founding was the unnamed hurricane of 1933. There are no local photographs of the actual storm that wrecked the convenient beach, only pictures of its after-effects: eroded cliffs, sharp drops to the water, driftwood and downed trees everywhere, boats no longer safe on the small remaining beach. Paradise was damaged but not lost. The community organized and fought back by building a bulkhead in 1937, adding huge rocks two decades later, and now planning to rebuild the old seawall in the constant battle of such shore communities against the rising sea. Hurricane Connie in 1955 was noteworthy for its fierce and long duration and for a tragic shipwreck, drowning 14 off the shores of Holland Point. The winds of Fran hit in 1996, and the deluge of Floyd followed in 1999. Isabel in 2003 caused a major evacuation, water damage, and the destruction of piers, but the local homes escaped. Small boats suffer mishaps every year in minor storms or when skippers misjudge the bay's dangers, and a body can wash ashore weeks later.

Nevertheless, the attractions of nature and her subtle changes continue to keep residents enthralled with the privilege of living by this great bay. Though the catch is smaller than 85 years ago, there remain rockfish, perch, flounder, and spot to be hooked. Migratory Canada geese and tundra swans visit. Crowds of sea ducks dive, mallards preen, herons pose, martins swoop, seagulls abound. The sweet climbing call of the osprey now frequently fills the air. Over the woods and wetlands fly eagle, cardinal, chickadee, nuthatch, blue jay, thrasher, robin, and four species of woodpecker. On the ground are deer, rabbits, squirrels, and, in wet weather, rare golden frogs and Maryland terrapins. The variety of trees remaining reminds us why the streets have tree names in this rare forest by the sea.

One

FIRST RESORTS
1900–1920

Though the eastern shore of the Chesapeake Bay gets much publicity for its insularity, the near western shore has long lured city people for quick respite and recreation without crossing the bay. Even in the late 19th century, a few nature enthusiasts had discovered these shores only an hour from the nation's capital. At the dawn of the 20th century, the bay featured clear water, bounteous oyster reefs, and fabulous fishing. But the area was launched popularly by the opening of the Chesapeake Beach Railway and Amusement Park in 1900. It was all dreamed up by Otto Mears, an entrepreneur from Denver, who attracted investors to create a luxurious Chesapeake Beach resort with festive boardwalks, a roller coaster, games of chance, a "mile long" pier, excellent beaches, a saltwater pool, cabanas, and hotels. The railway and steamboat carried thousands out from Washington and down from Baltimore to discover the convenience and delight of the newly developed western shore. It became popular for family outings and organizational events sponsored by such groups as Washington newspapers, a lawyers' group's shad bake, and the Red Cross.

From Chesapeake Beach grew the next community, North Beach, a mile up the road by electric trolley, Ford, or foot. It offered its own wide beach, a pier, restaurants, and amusements as well as basic services such as dairy, grocery, and two drugstores. From the beginning, it was laid out as a more conventional village than Chesapeake Beach, which was clustered around the amusement park. North Beach had nine named streets (later numbered) perpendicular to the bay and room for numerous avenues to cross them. Chesapeake Avenue became the main street and was a continuation of the road from Chesapeake Beach. North Beach's Bay Avenue became the place for independent summer fun, with its ballroom, restaurants, fishing pier, and a commodious swimming beach. Hotels and small cottages sprang up as the town developed. In 1918, Emma Ewald moved her Washington, D.C., bakery to North Beach. The family business flourished and grew to include a market, restaurant, and dry goods establishment. At the start of the 1920s, there were many businesses, including a bait store and an A&P. The town was ready to support additional homeowners and their families, but the road north ended at the creek at the Anne Arundel County line. Enter Holland Point Realty.

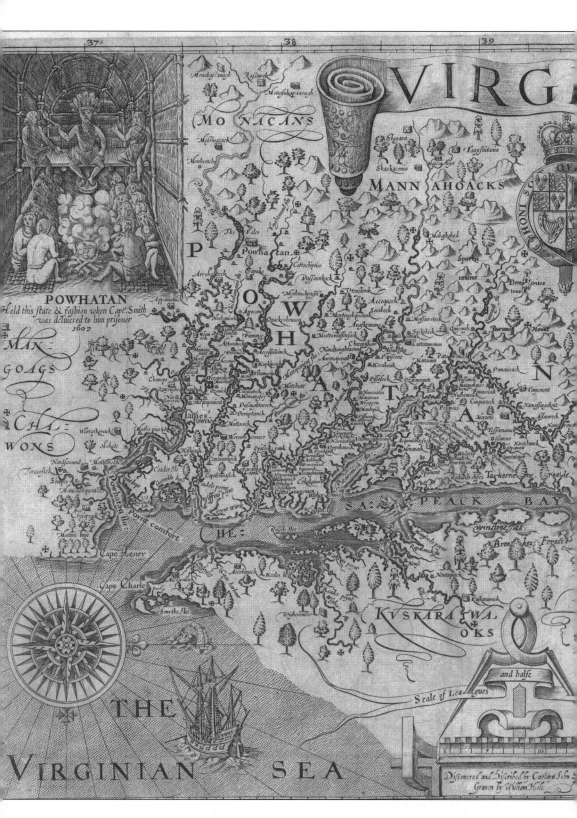

VIRG̃A

MONACANS

MANNAHOACKS

HONI SO

POWHATAN

POWHATAN
Held this state & fashion when Captᵉ Smith
was deliuered to him prisoner
1607

MAR-
GOAGS

CHE-
WONS

James
Towne

Cape Henry

Cape Charles

Smyths Iles

PEACK BAY

winstons Iles

Brookes Forest

KVSKARAWA
OKS

Scale of Leagues

and halfe

5 10

THE

VIRGINIAN SEA

Discouered and Discribed by Captain John S.
Grauen by William Hole

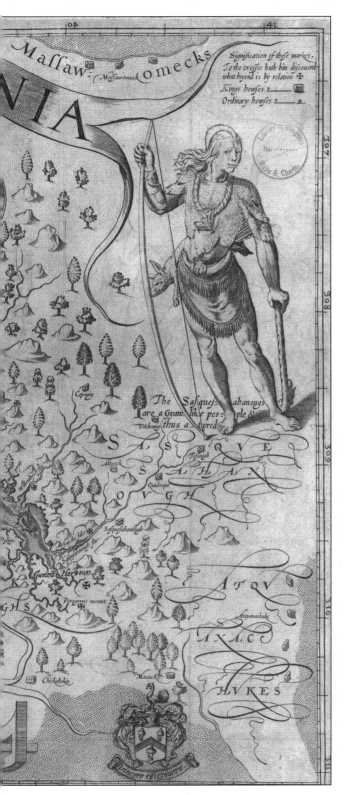

This map is entitled, "Virginia, discovered and discribed [*sic*] by Captayn [*sic*] John Smith, 1606; graven by William Hole." It is the 1624 version, in its sixth rendering and published in London, of the much copied and revised original 1612 map resulting from Smith's two pioneer voyages in 1606 and 1608 exploring the Chesapeake Bay area. Oriented with north to the right, the "Virginia" colony map predominantly shows part of the future state of Maryland, including where, in 1608, Captain Smith and his crew sailed close by Holland Point during their futile search up major rivers for a passage to the Orient. What they found was a nice place to spend the night: the beach at what is now nearby Rose Haven. The 1624 map is kept in the vault of the Library of Congress Geography and Map Division. (LOC.)

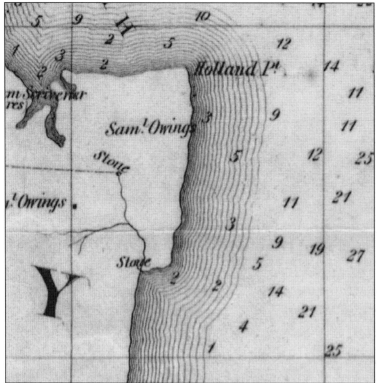

In 1860, Simon J. Martenet created *Martenet's Map of Anne Arundel County, Maryland* from U.S. Surveys showing "shore lines, soundings, etc." The detail features the "Holland Pt." area and the land owned by Sam Owings, whose name survives today in the nearby village of Owings. Two stones shown mark the county's southern boundaries. The lower one has been washed away, but Holland Point residents rediscovered the upper stone in the woods in the 1990s. (LOC.)

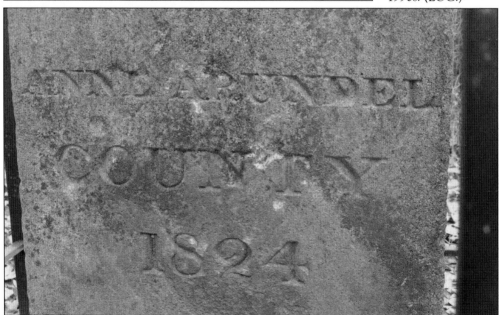

In the 1990s, Holland Point residents Bernard "Bernie" Loveless, Sheila Stout, and Janet Bates renewed interest in preserving an old granite marker stone deep in the woods near the southwest end of Holland Point. The location of the county line there had been disputed until the 1822 Maryland Assembly agreed to a new survey. The resulting stone was dated 1824 and engraved with "Calvert County" on the south side and "Anne Arundel County" on the north side. (DM.)

In 2000, the Holland Point Citizens Association received an $800 county grant for creation of a 6-foot-high iron fence to protect the fading marker. A working committee, including Bernie Loveless, Joy Baker, Melinda Zimmerman, Wes Copeland, and Mike Webber, contributed the labor of setting up the historic monument. Below, Copeland supervises as Zimmerman mixes cement. (Right VW; below JL.)

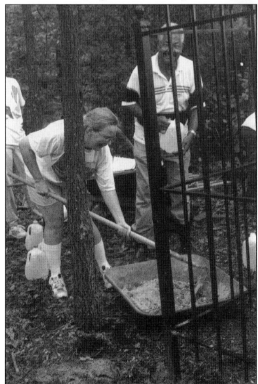

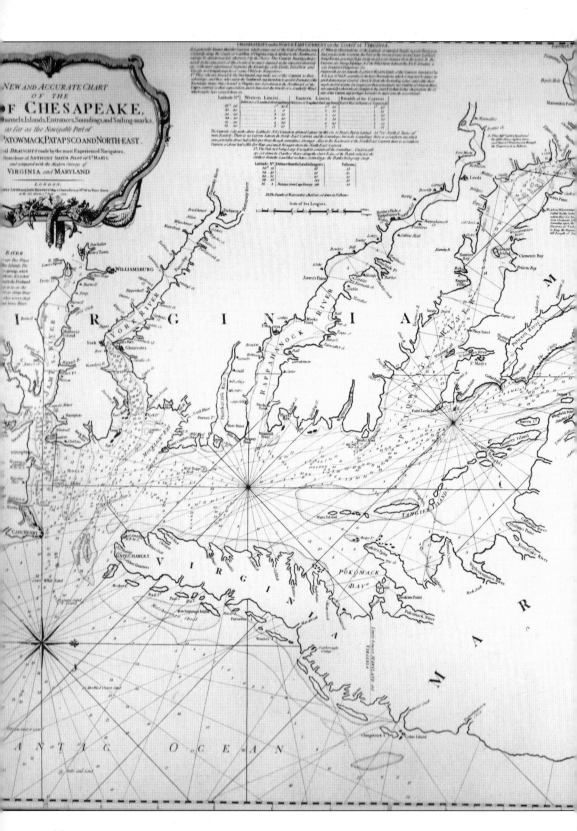

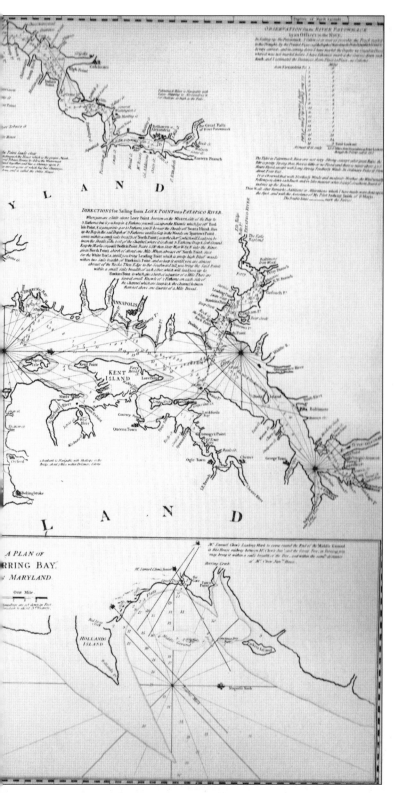

This 1776 "New and Accurate Chart of the Bay of Chesapeake" was attributed to Anthony Smith, pilot of St. Mary's County. It actually derives from Walter Hoxton's 1735 "Mapp [*sic*] of the Bay of Chesapeake." Hoxton was associated with a London tobacco firm. Claiming to have surveyed most of the bay himself, he charted details of currents and navigation. Hoxton devotes an entire inset to Herring Bay. In the 18th century, this western inlet hosted major ports, such as the one then in Herrington (now Fairhaven), used for tobacco and slave trade. The inset features an extensive "Holland's Point," at that time jutting far out into Herring Bay. The land also was clearly labeled Holland's Island. Inland creeks and wetlands, combined with farming in the 19th century, subsequently filled in land to convert island into marshy peninsula. (LOC.)

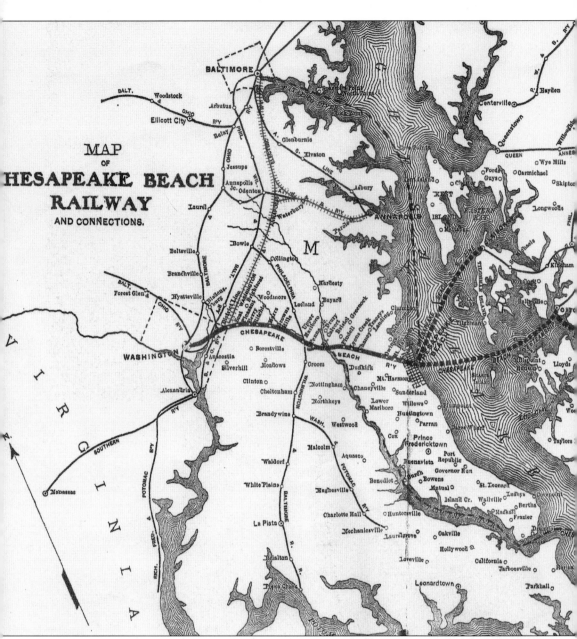

This *c.* 1900 map shows the grand plans for the Chesapeake Beach Railway and its connections. The line from Seat Pleasant at the edge of the District of Columbia to the brand-new Chesapeake Beach Resort opened June 9, 1900, and ran until 1935, delivering many thousands of passengers over this period to the beach resort, which spurred the growth of western shore communities. Also conceived by visionary Otto Mears (1840–1931) and his associates, two other lines never materialized: the Chesapeake Beach Steamship Line to Claiborne and Oxford, Maryland, on the eastern shore and another steamship line down the Patuxent River to Solomon's Island and across the bay and up the Nantikoke River. The steamships were to connect directly with the rail line for luxurious 20th-century travel—fantastic plans by a maker and shaker who was also a great dreamer. (CBRM.)

This half stereograph shows an oyster tonger in 1905 carefully culling from the Chesapeake. Tonging was the labor-intensive, shallow-water method that was adopted from the natives. Other methods include hand digging while standing in the water and the more drastic dredging from single-masted skipjacks, now nearly extinct. The 19th-century Chesapeake Bay "oyster wars" nearly depleted this resource. (LOC.)

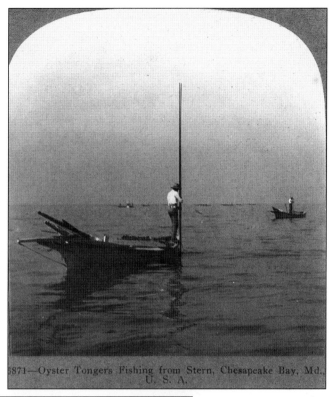

871—Oyster Tongers Fishing from Stern, Chesapeake Bay, Md., U. S. A.

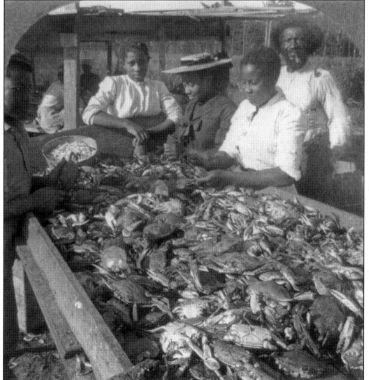

This 1905 stereograph shows workers picking crabs for market on the banks of the Chesapeake Bay in Maryland. Though the crabs are smaller a century later, the employment of "pickers" continues, along with the popularity of crab cakes and spicy Maryland vegetable crab soup. (LOC.)

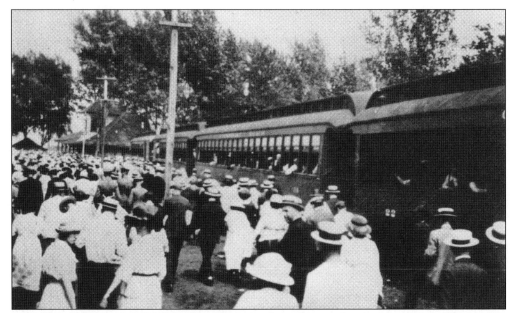

The Chesapeake Beach Railway brought countless thousands of visitors from all over the Washington, D.C., area to the beach from 1900 to 1935. This postcard, *c.* 1923, shows the hordes of tourists dressed up for a convenient ride to the beach and a fine day in the country. The railway also stimulated the growth of communities just to the north of Chesapeake Beach itself: North Beach in Calvert County and North Beach Park in Anne Arundel County. (CBRM.)

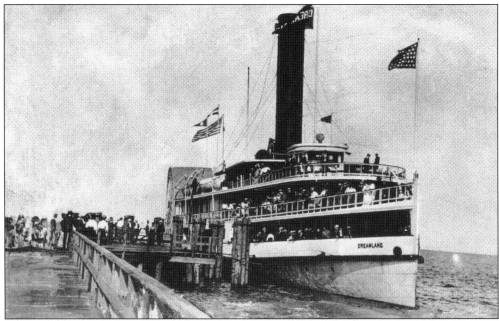

The *Dreamland* was one of the most popular steamships bringing tourists to the new Chesapeake Beach resort. It made daily excursions from Baltimore and back during the summer months between 1912 and 1925. Here it is shown delivering hundreds of passengers to the famous mile-long pier to begin a day swimming or just enjoying the boardwalk amusements along the waterfront. (CBRM.)

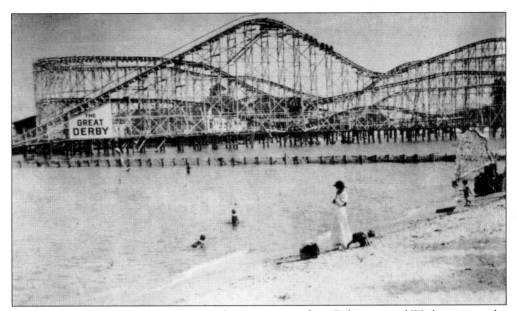

The Great Derby was a major attraction drawing tourists from Baltimore and Washington to the new seaside resort at Chesapeake Beach. This *c.* 1900 photograph of the elaborate new "scenic railway" or roller coaster shows that much of it was built out over the water for added thrills. Less adventurous customers could enjoy bathing in the placid waters off the wide beach or riding a fine carousel built by Gustav A. Dentzel. (CBRM.)

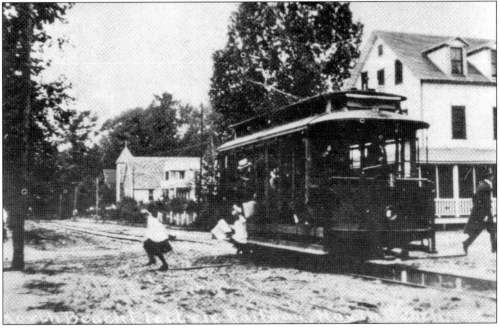

The North Beach Electric Railway ran one and a quarter miles from Chesapeake Beach between 1914 and 1918. It ran again from 1921 to 1923, when a Fordson tractor was brought in to pull a former horse car. Early residents of North Beach Park could ride the trolley up to their unpaved access road. This 1910 postcard photograph of the somewhat unreliable trolley arriving in North Beach shows the old Sinclair Hotel and St. Anthony's Church in the background. (CBRM.)

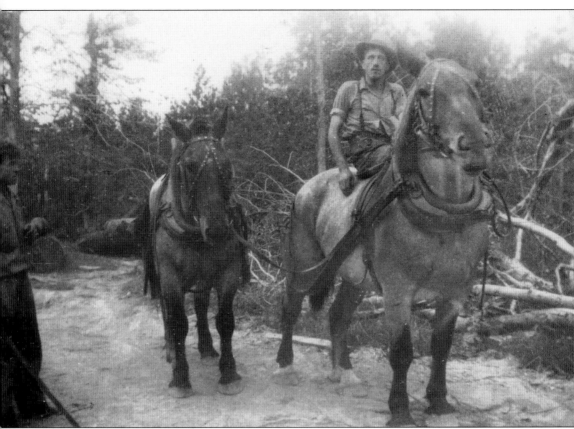

This rare photograph records the work of loggers in the early 1920s who cut down trees from the upland forests on the former Holland Point Farm. With horses or donkeys, they hauled them out of the woods over dirt paths from the logging camp at the end of Myrtle Avenue. Some of the resulting lumber went into building the first cottages of the new North Beach Park and some was used for minesweepers during World War I. Old-timers recalled that some of this lumber also was shipped to the more sparsely wooded Eastern Shore for boatbuilding. (JL.)

Two

FOUNDING FATHERS

THE 1920S

The Holland Point community was conceived in 1922, when John W. Hayes and Gibbs L. Baker formed the Holland Point Realty Company. Hayes was local, but Baker was a prominent lawyer from Washington, D.C. They purchased the Holland Point Farm from Matthew Lyons, who may have intended to be a third partner but died in 1922, leaving two-thirds ownership to Hayes. Lyons had bought it in 1919 from Ridgeley and Augusta Melvin: 309 and a quarter acres, mostly in Anne Arundel County, with 16 acres in Calvert. The new owners surveyed and platted it in 1922 and renamed it North Beach Park, a name that stuck for over 50 years.

A pioneer who purchased one of its hundreds of small lots generally was seeking a private place for family enjoyment. The land was untamed and the dirt road primitive and overgrown. Eugene Vincent Young Sr. remembered the first time his father, Wootton Young, took him in an old Ford touring car to see the lot he purchased in 1922. They then trekked through briars, underbrush, and water. The lot was covered with stumps, fallen tree limbs, and puddles of stagnant water, but it faced the bay. At the time, he thought his father must be crazy, but he soon saw the wisdom of the purchase. Some new owners could first afford only to pitch a tent on their lots, but sales and building boomed. Soon there were 150 cottages facing or near the bay. With swimming and boating, families had their own beach in a park-like setting only an hour from the city.

Cross streets were given alphabetical tree names starting with Ash. Later Gibbs Baker declared that no new businesses were to be started in this residential community, except for the Burgess rowboat rental near Ash and Margaret Sinyard's popular inn and restaurant. Residents pumped and carried water from the artesian well near the Bakers' cottage. Concerns such as erosion, bay front rights, and the state of the corduroy (log and sand) road caused the organization of a North Beach Park Citizens Association in 1927. The first meeting was held at the home of Harry Seabridge, with Robert Estes serving as president until 1929. There were 61 charter members, each paying $1 dues. During winter, they met in Washington homes, hotels, or at the YMCA. Summer meetings and events included horseshoes and pretty baby contests, giveaways, and demonstrations by the North Beach Fire Company. These were among the happiest and most carefree years in the new community.

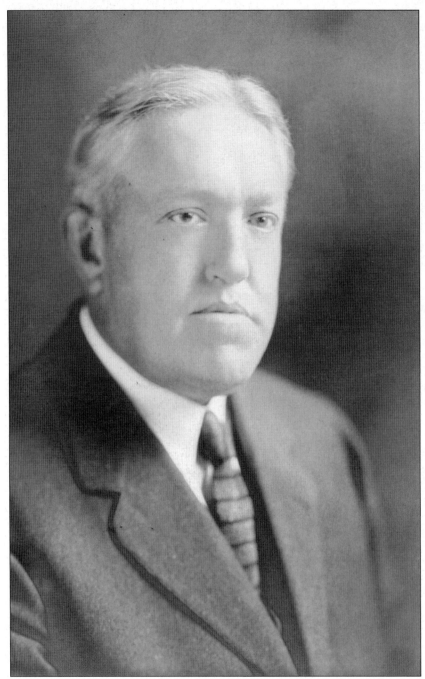

Gibbs Latimer Baker (1874–1939) was a prominent Washington, D.C., lawyer whose cases were publicized in major city newspapers. He founded the community of Holland Point in the early 1920s and developed it under the name of North Beach Park. Partnering with John W. Hayes, he purchased the entire Holland Point Farm on March 6, 1922, from Matthew Lyons. After the death of Hayes in 1925, Baker became full owner. He and his wife, Caroline, owned a cottage in the Park and had a major influence in its governance until his death in 1939. This photograph was located at his granddaughter's San Francisco home. (LB.)

Caroline Banister Pryor Baker (1878–1960) was Mrs. Gibbs L. Baker Sr. and for many years co-owned with him all the unsold lots in North Beach Park. She came from an old Petersburg, Virginia, family and claimed to be a ninth-generation descendant of Pocahontas. She was a Washington socialite whose comings and goings were noted in the social columns. The well-educated children of Gibbs and Caroline were Caroline Baker BickerCaarten and Gibbs L. Baker Jr., who became a Washington attorney and the father of Lisa Pryor Baker and Juliet "Judy" Platt Baker DeSouza. (LB.)

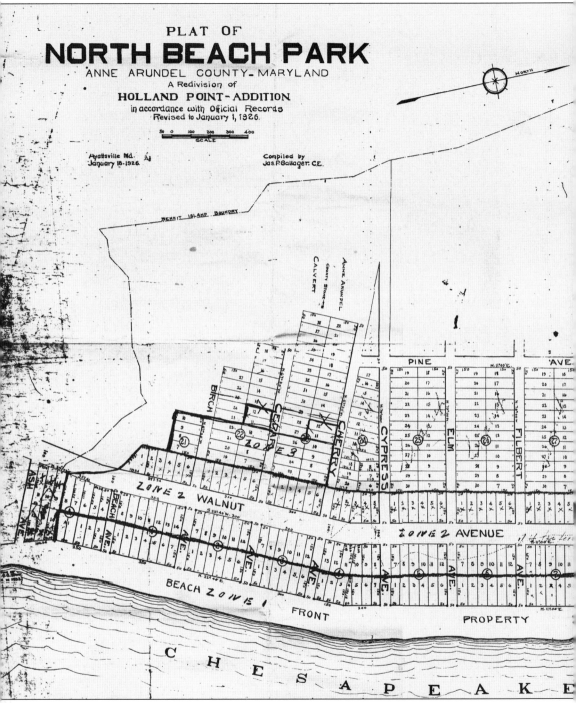

The community was first surveyed in 1922 by Edward L. Latimer, who drew the "Plat of North Beach Park, a Redivision of Holland Point Addition." In a 1924 version, the lots were renumbered and a few irregularities removed. Like the others, this 1926 plat, compiled by civil engineer Joseph P. Gallager, also projects a densely developed community. The Depression may have saved the trees: as of 2007, oak, holly, and paw-paw forests and sometime swamps still exist west of Walnut

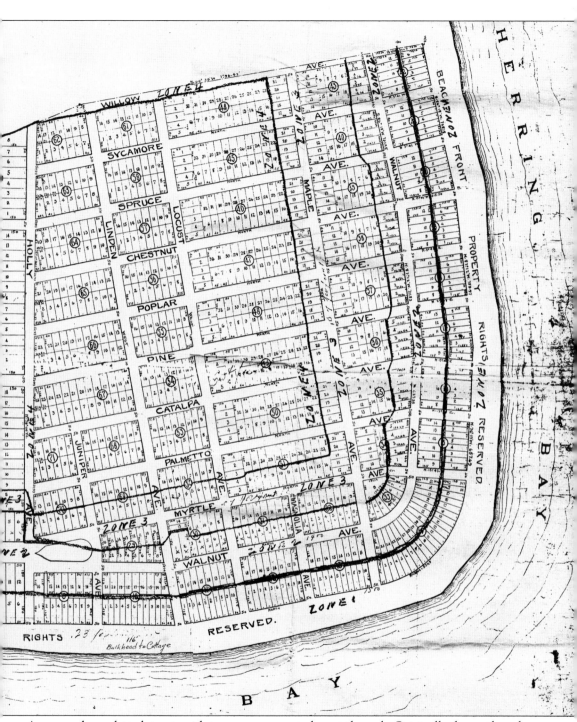

Avenue, where platted streets with tree names were to be cut through. Originally the south end logically began with Ash Avenue, which has washed away. This plat makes clear that the entire community has rights to the beach front, an understanding that remains to the present. Myrtle and Walnut Avenues have developed from dead-end dirt walking paths through the woods to now busy paved thoroughfares. (JEB.)

NORTH BEACH PARK LOTS Are on the seashore and the New State Road one and a half hours from Washington, D.C.
by automobile or train. Good roads and steamboat service from Baltimore and Annapolis

SALT WATER BATHING SAILING CANOEING FISHING CRABBING OYSTERS SHADE TO THE BEACH
COUNTRY PRODUCE HOTEL ACCOMMODATIONS AMUSEMENT PARK NEARBY SAFE BEACH FOR THE CHILDREN

ROBERT B. CASON
PRESIDENT

REAL ESTATE

BUILDING

THE NORTH BEACH COMPANY, INC.

North Beach, Md. August 20, 1923.

LUMBER

MILLWORK

BUILDING

MATERIAL

Received of August Voigt, P. H. Moreland and A. H. Moreland
the sum of Two Hundred-Forty Dollars ($240.00) as advanced
payment in full for furnishing material and building tent
platform 16' x 16' and one frame garage the same general style
and dimentions, without cement floor as the one now on the
back of Mrs. Hines' lot at North Beach, Md.

It is further agreed by me that lots 3 and 4,
Block 10, and the space in front of said lots will be
cleaned of underbrush and all dead and down timber.

The above buildings to be built on Lot #4, Block
10 at North Beach Park, Md. within one week from time started.

Robt B. Cason

In 1923, August Voight and brothers Paul and Arthur Moreland contracted for the building of a tent platform and garage near Juniper Avenue. At that time, lot owners like Voight and the Morelands had to hike about a mile into their property while construction took place. This agreement and advance payment receipt provided for a basic campsite while the cottage was built. It would have to have been very basic to be completed in one week. The Moreland wives, Mabel and Louise, may have waited for the house's completion before traveling to the new community to spend the summer or even a night. (KY.)

This 1980s photograph pictures an original cottage built in the 1920s by the Voight and Moreland families. Receipts for lumber and other items to build the house show that the total cost came to about $2,000. Many of these early homes had dark-stained interiors, which made for very gloomy rooms when northeastern storms struck. At these times, board games and decks of cards kept children and adults alike entertained until they could venture outside again. (KY.)

This is a contemporary view of a dynastic block. On the left is the Bates cottage, dating from 1923. Next is the 2005 home of Kathy and Woody Young, which incorporates, as its master bedroom, the original Moreland home Kathy acquired after the death of her mother, Miriam Cheston. Woody's brother Eugene Young recently rebuilt his old cottage as the next tall house, and on the right is their brother Raymond's home, shared with wife, Nancy Bates Young. (JP.)

In the early 1920s, the still-unfinished Woolnough cottage appears on the bay front near Juniper Avenue in its classic bungalow-style simplicity. This type of construction was typical of the period. (RR.)

At the rear of their summer cottage, Charles and Johanna Woolnough are shown in the 1920s with daughter Marie standing on the step. Marie was an unmarried schoolteacher, and the family's main home was in Chevy Chase, an hour to the northwest. (RR.)

North Beach Park

This Deed, Made this ___Sixteenth___ day of ___August___, 192**6**, by and between Gibbs L. Baker and Caroline P. Baker, his wife, of the City of Washington, District of Columbia, parties of the first part, hereinafter called "GRANTORS"; and __JOHANNA WOOLNOUGH__ _____ of ___Washington, D. C.___, part**y** of the second part, hereinafter called "GRANTEE."

Witnesseth: That for and in consideration of the sum of ___FOUR HUNDRED & FIFTY___ Dollars ($__450.00__), and other good and valuable considerations, the receipt whereof in full is hereby acknowledged, the said GRANTORS do hereby grant and convey unto the said GRANTEE ___her___ heirs, successors and assigns, in fee simple, all those lots or parcels of ground located in Anne Arundel County, Maryland, in the development known as "NORTH BEACH PARK, A RE-DIVISION OF HOLLAND POINT ADDITION TO NORTH BEACH," which are designated as Lot___13___ of Block___9___, according to the plat of said "NORTH BEACH PARK, A RE-DIVISION OF HOLLAND POINT ADDITION TO NORTH BEACH," duly recorded among the Plat Records of Anne Arundel County in Liber W. N. W., No. 2, Folios 30 and 70.

BEING a portion of the same property which was conveyed unto John W. Hayes and Gibbs L. Baker, by Matthew Lyons, Bachelor, by deed dated March 6, 1922, and recorded among the Land Records of Anne Arundel County in Liber W. N. W., No. 54, Folio 273, in which deed further reference is given to the chain of title to said property. The complete fee simple title to said property having become vested in said Gibbs L. Baker by deed from John W. Hayes and wife, Ridgely P. Melvin and wife and Gibbs L. Baker and wife, dated May 8, 1925, and duly recorded among said Land Records.

TOGETHER WITH the buildings and improvements thereon, and all of the rights and appurtenances thereto belonging, or in anywise appertaining.

To Have and to Hold the above described property unto the said __JOHANNA WOOLNOUGH_____, ___her___ heirs, successors and assigns, in fee simple, SUBJECT, HOWEVER, to the following covenants, conditions and restrictions, which shall be taken and construed as running with the land and forming a part of the consideration.

1. No more than one dwelling house shall be erected on any one lot and such dwelling shall not cost less to build than one thousand dollars.

2. No business of any kind, class, or description shall be conducted on said premises without the written permission of the said Gibbs L. Baker; no spirituous or malt liquors shall be made, sold or kept for sale on the premises; no nuisance, or offensive, noisy, or illegal trade shall be permitted on the premises; no building shall be erected within twenty feet of the front line of said property.

3. Said property, or any building erected thereon, shall not be occupied by any negro or colored person or any person of negro extraction, or any person of African descent.

4. The property conveyed is described, defined, and limited by the lot and block number of the subdivision known as "NORTH BEACH PARK, A RE-DIVISION OF HOLLAND POINT ADDITION TO NORTH BEACH," as filed and recorded in the Land Records of Anne Arundel County, Maryland, as aforesaid.

5. Any alterations, erasures, or interlineations shall render this deed null and void, unless and except the alterations, erasures, or interlineations shall be initialed by one of the grantors.

And the said GRANTORS do hereby covenant that they will WARRANT SPECIALLY the title to the property hereby conveyed, and that they will execute such other or further assurances of the same as may be requisite.

WITNESS THE HANDS AND SEALS OF THE SAID GRANTORS.

WITNESS:

Gibbs L. Baker [SEAL]

S. A. Gentry. _Caroline P. Baker_ [SEAL]

This deed is for the property behind the home of Charles and Johanna Woolnough. The home had been built on the bay front earlier. Of special interest are the signatures of Gibbs and Carolyn Baker signed in 1926. Houses were inexpensive, and often the wood was brought in from the lumber mill in the forest nearby. There was no indoor plumbing in the 1920s, and everyone had outhouses as well as hand pumps in the kitchens or outside. Some of the outhouses are still standing today and are used as sheds for storage. It would be several years before electricity came in from Chesapeake and North Beaches. Until then, oil lamps were used throughout the Park for light. Many of the original families still use them during power outages. (RR.)

Sisters Gertrude Volland (left) and Magdalena "Lena" Volland pose in the waterfront forest in 1922 near a Model T Ford and picnic table. The earliest resident families scouted out lots in the wooded area above North Beach before buying land and building new cottages in what became North Beach Park. Gertrude later married Miles Miller, and Lena married a Raulin son. The Miller, Raulin, Volland, and Wurtz families were early settlers of the new community, and many of their relatives remain. (MT.)

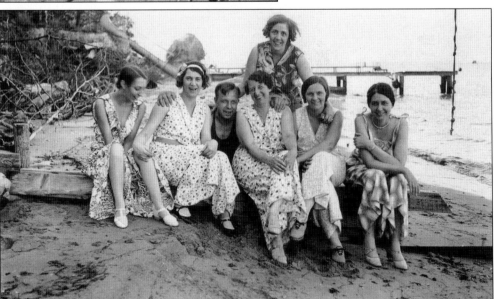

Members of the First Reformed Church of Washington, D.C., came out to enjoy a beach party in 1929 in front of the Miller family cottage. The women are sporting "beach pajamas," which were popular at the time. Gertrude Miller is second from the left. (MT.)

For social life, many young Holland Point residents gravitated to the public playground of North Beach just down the road. Here Mary McQueen tops a pyramid of friends in front of the popular North Beach dance pavilion in 1929. (LS.)

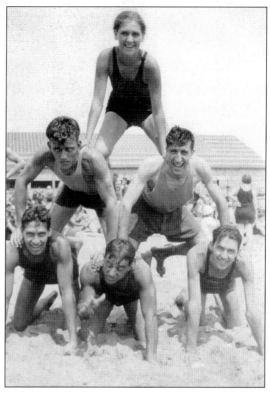

In 1929, Mary McQueen was one of the outstanding local beauties, whether on the beach in North Beach or in Holland Point. (LS.)

Rose and Joseph Patane owned this cottage on Walnut Avenue when this c. 1932 picture was snapped, showing Rose with son Albert. The family's double wooden garden swing was typical of the period and provided friends and family a simple, inexpensive outdoor pleasure and a place for conversation, meditation, and sometimes laughter. (AP.)

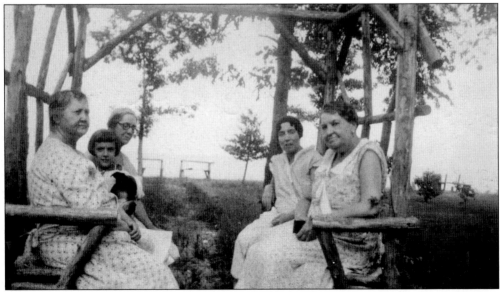

All wearing plain cotton dresses, clockwise from left, Mollie Prender, Virginia Clark, Virginia Bessman, Edith Prender Clark (Virginia's mother), and Ella Bell sit in front of the Bessman cottage on the bay front in 1928. Their rustic seating set is handmade from tree branches. The former Bessman cottage has been owned by the Sword family for many years. (VC.)

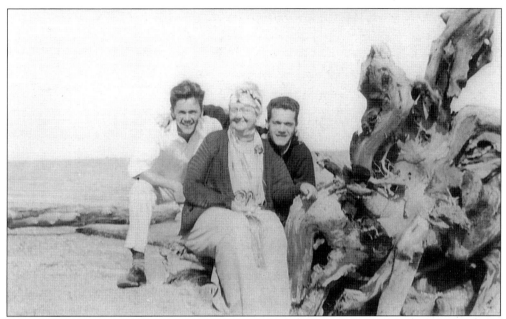

Nita Parker poses with huge driftwood and sons Douglas, on the left, and Howard "Buzz" on the beach in front of their cottage in 1928. Large drifted roots such as this one fell onto the beach after heavy storms eroded the treed shoreline. Some debris may have come down from upland logging for house construction. Doug later became a patent lawyer and Buzz an obstetrician, both practicing in Washington, D.C. (AP.)

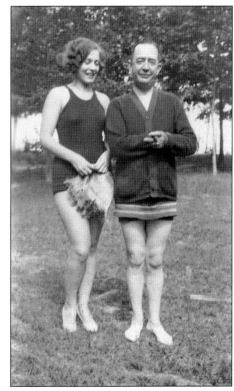

Wootton Young owned G. W. Cochran Company, a tobacco and sundries distributorship in Washington, D.C., and lived primarily in the city. He is shown here with his daughter-in-law, Mary Young, in the 1920s near the original cottage he had built in the Park, where he and his growing family derived much pleasure on the weekends and summers for many years. (NY.)

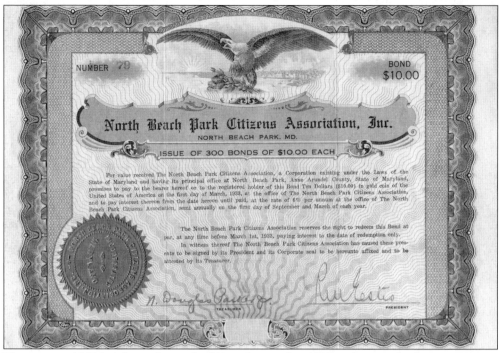

This is one of 300 bond certificates for $10 each issued in 1928 to finance the first community association building after five years of meetings in homes and hotels in the community and in Washington, D.C. It is signed by Robert Estes, the first president of the then North Beach Park Citizens Association, and by Douglas Parker Jr., treasurer. (HPCA.)

Gibbs Baker donated the two lots for the original clubhouse, which was built in 1928. It was used for all association events until 1934, when it was sold back to Baker to resolve association debts due on the loan. It remained vacant for many years before being renovated as a residence. (JP.)

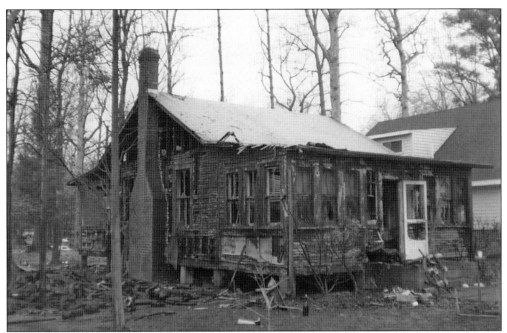

The burned-out house shown in this picture belonged to Webb and Marjorie Wyman, who had used it with their two sons, Lyle and Lehr. Lyle followed in his father's footsteps to become a dentist, and he then married Carol Wondrack. The Wondrack family had also been summer residents in Holland Point. Lyle, Carol, and their children, Bruce and Claire, occupied the Wyman home until 1982, when a fire that burned down the neighboring Raulin house destroyed the Wymans' house as well. Two other adjacent homes were damaged by this fire. A new house was built by Lyle and Carol. She completely renovated it in 2005, as shown below. Today Carol is a full-time resident here. She and her children and grandchildren can now again take full pleasure from this home. (RD.)

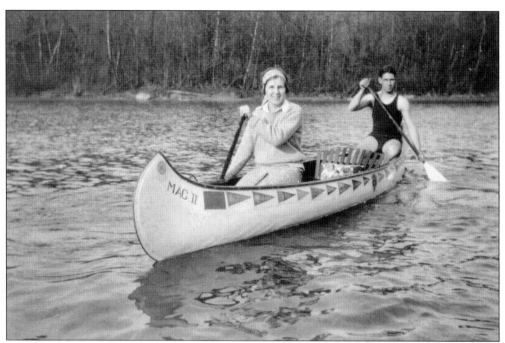

Mary McQueen and her brother James "Jim" McQueen paddle their canoe, the *Mac II*, around the actual Holland Point into Herring Bay in the 1920s. (LS.)

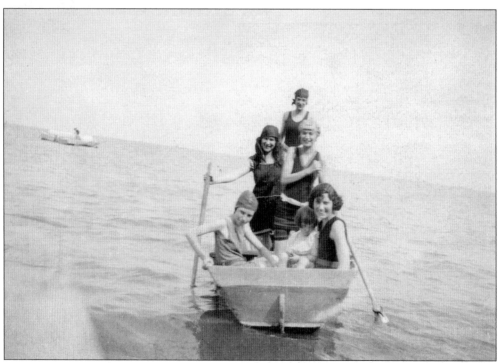

In the 1920s, most residents depended on simple rowboats for water recreation. In this rowboat are Mildred Volland (later Wurtz), Gertrude Volland (later Miller), Vesta Miller, Helen Kelly, Jean Volland (child), and Louise Kelly. (MT.)

Before their marriage, Doug Parker courts Ruth Brashears in 1927 on the beach in front of his mother's cottage. They had two children, and their daughter, Ann, still lives in the family house in Holland Point. (AP.)

Seated on a pier, Eugene Young Sr. hugs his fiancée, Mary, before their wedding in 1929. Their marriage lasted over 50 years and produced three sons. Many such romances bloomed on the bay front. (NY.)

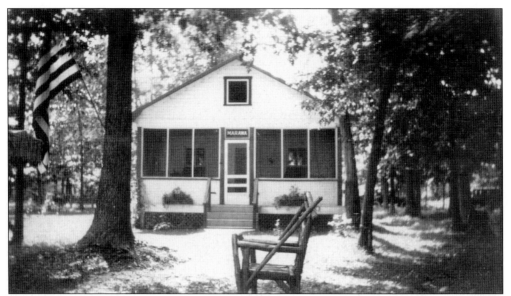

Marion and Mamie Federline built one of the early cottages, on the bay front between Linden and Locust Avenues, as a summer place for the family. This 1928 image shows the still thickly forested, grassy waterfront into which the home, Marawa, was fitted. (HL.)

In 2007, the original Federline cottage was razed and this large modern house replaced it. The home is owned today by Helen Federline Lidie, great-niece of the original settlers. (JP.)

In 1997, Dave and Margaret McKenna purchased the altered 1920s home seen above. He has traced the ownership of the property at Bayfront and Locust Avenues back to 1903. Deeds were recorded then from a 19th-century Nettie P. Proust to trustees Sam Owings Jr. and Joseph Birkhead. Ownership went to John Hayes and Elizabeth Galbraith in 1912 and then to Mathew Lyon in 1919, from whom Gibbs Baker and John Hayes purchased it in 1922—along with over 300 other acres known to have transferred from farmland to the development of North Beach Park. Subsequent buyers were Mary Roach, 1929; Henry and Marian Surface, 1937; Louis and Mary Hall, 1939; Gladys Eastham, 1943; Morse and Helen Allen, 1950; and Helen White, 1988. The McKennas have completely renovated the home, as seen below in 2006. (Above SS; below JP.)

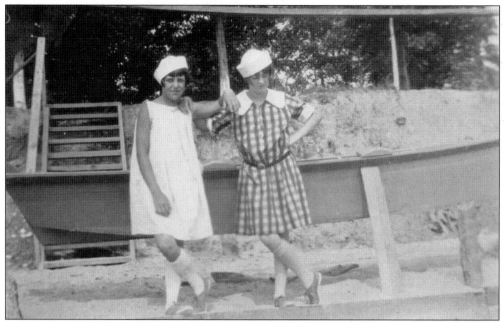

Miriam Moreland, later Cheston, (left) poses on the beach with a friend in 1928 sporting their fashionable sailor hats. A rowboat was always ready at hand on the wide beach, just a few steps down the original embankment. (KY.)

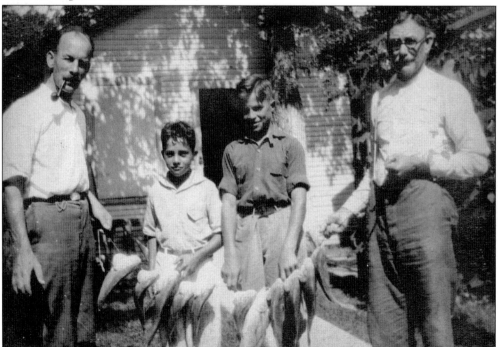

Arthur H. Moreland (right) and three friends are shown with their fine catch of hardhead and perch in the summer of 1924. They are standing in front of the recently built Moreland garage. This garage still stands behind the original home, which has been thoroughly renovated over the past few years. (KY.)

Standing from left to right, Harley Buckingham visits with cousins Buzz and Doug Parker and a friend in front of the Parker family cottage in 1926. Four years later, Harley's parents would purchase a nearby 1923 cottage, which remains in the family, unchanged except for modern amenities. (AP.)

In 1927, debonair Doug Parker's bathing costume was in high fashion. Until 1933, residents casually kept their rowboats safely on the wide beach all summer long, as seen in this view. (AP.)

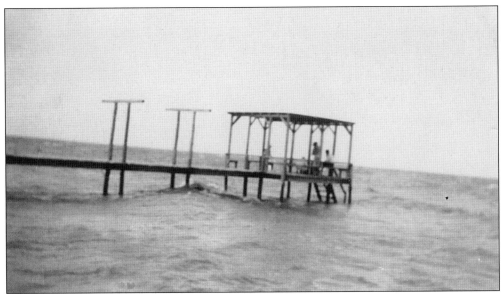

Covered piers, such as this unusual one shown in 1928, were not very sturdy in withstanding the buffeting of the many storms common to the area. In the 1990s, the Holland Point Citizens Association revised the articles of its constitution to prevent such structures and related barriers from being put up because they threatened to impede views of the bay admired by all. (HL.)

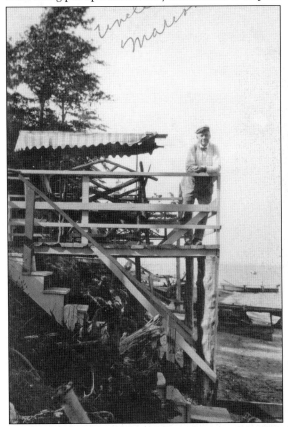

Standing on his unique lookout platform in front of their cottage, Marion Federline looks south over the bay in this September 15, 1929, photograph. Marion and Mamie Federline built their original cottage behind this overlook. (HL.)

A deep beach in 1927 and huge driftwood provided a playground for James "Jim" Bowen and his two-year-old daughter, Beverly. Mildred Griffith tops the driftwood. Beverly Bowen Page still owns the original home. (BP.)

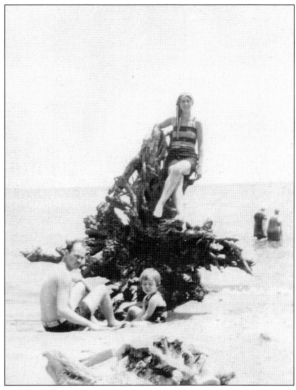

Years before the great storm of 1933, warnings were already present of natural threats to the beachfront. Here in the summer of 1929, Gertrude Miller (third from left) and visiting friends are amazed at the deep erosion under the land between beach and homes. (MT.)

In 1931, the beach was a wide expanse on which canoes and wooden beach chairs could be left without a care. Here Nita Parker relaxes while her family plays. One of the favorite activities was searching for fossilized sharks' teeth reputed to be 16 million years old. People also liked to look for "beach glass"—pieces of broken bottles whose edges are rubbed smooth by the sand and tides. Amber beach glass was even used as a lens through which to safely view the solar eclipse of August 1932. (AP.)

Three

HARD TIMES

THE 1930s

After the Depression hit, people needed to protect their investments and limit liabilities. In 1930 and 1931, Gibbs Baker deeded Walnut and Myrtle Avenues to Anne Arundel County for upkeep as public roads and for utility connections. Lots were no longer selling quickly; four women even tried to sue Baker because he had encouraged them to invest. In 1934, being the last living owner of the original Holland Point Realty, he transferred to the company all unsold lots and blocks of land along with all cross streets and riparian rights and added his wife, Caroline, as co-owner.

In formal letters to the Holland Point Citizens Association, Baker made clear that the bay front was for all residents and no fences or buildings were to be erected there. Association presidents during this decade included Mary Seabridge, Herman Burgess, and E. M. White. The association had to return the first clubhouse to Baker because of their inability to pay off the bonds due on it. During this period, Walnut Avenue was a tar and gravel road, which was widened in 1938. On July 6, 1933, the association met to discuss getting federal support to protect the property from water erosion, and six weeks later, nature struck hard.

The area had a history of hurricanes documented back to 1667. When the big one hit in mid-August 1933, hurricanes were still unnamed. It was a category-four Cape Verde storm that roared for two days in advance of its arrival. Four days of pelting rains followed, with black skies, howling winds, and major flooding. The estuary's rivers turned yellow on August 19 and spilled millions of gallons of freshwater and sediment into the bay, damaging oyster beds. A huge mound of water, a "tidal bore," combined with the 9-foot-high sea level to feed energy into a giant flood up the Potomac River and into the Chesapeake Bay. After the storm, 35–100 feet of the beach and shoreline were gone. Huge trees were down everywhere and floated in the water along with parts of piers. In 1937, after four years of petitioning federal and local authorities to assist the community with the wrecked shoreline, the association, with the invaluable assistance of Wootton Young, worked towards and obtained financing for a bulkhead to protect their waterfront. The building contractors, Crandell and Brundage, built the bulkhead with 20-foot-long wooden jetties against the land banks to fortify what had once been beach.

In 1935, the Chesapeake Beach Railway closed down. In 1939, Gibbs Baker died. An era ended.

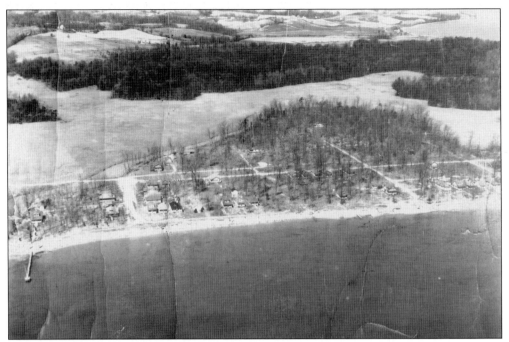

The 1930 aerial photograph of the beach in winter at the south end of Holland Point, from block 1 to block 4, also shows the swamp area on the western edge of Holland Point. It looks almost the same as it does nearly 70 years later. (RR.)

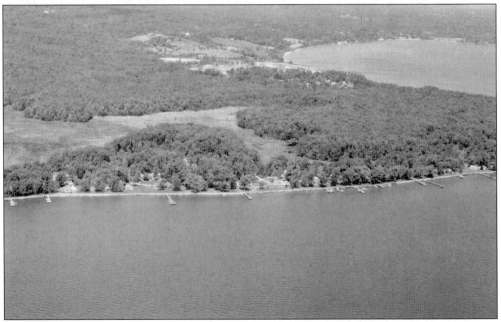

The 1997 aerial photograph here shows the same scene in summer. Holland Point is backed by wetlands that remain from the period when it was an island. Protection of such tidal wetlands is guaranteed by federal law, though insistent development is often difficult to control. Water birds and turtles frequent these shallow tidal waters, which absorb big rains and change with the weather. (JB.)

This simple 1935 seaside birthday party photograph shows, from left to right, James "Jim" Housten, Fred Raulin, Jean Volland, Miles Miller (the birthday girl), Gert Housten, and Robert "Bob" Wurtz. Miles was named for her father, who died in a hunting accident across the bay before she was born. (MT.)

Young neighborhood friends gather on the steps leading down from the new seawall to the diminished beach around 1938. From left to right are (first row) Leo and Mary Jean Stock; (second row) John "Jack" Hartke, Ann Parker, and Ellen Hartke. Jack later served as president of the Holland Point Citizens Association. Ann Parker Parks still lives in the community and is an active officer in the association. (AP.)

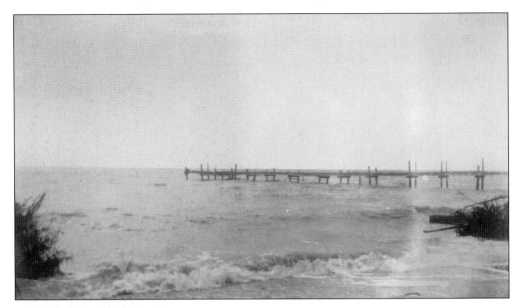

The pier above was built by Harry High in the early 1930s on the bay directly in front of Hemlock Avenue. After this pier was gone, another pier, seen below in 1975, with many neighboring families involved as co-owners, was built to replace it around 1950. Both of these piers were the longest in Holland Point and afforded good fishing at the end far from the shallow shore. After surviving many storms and sporting multiple repairs, this last pier, known as "the white pier," was finally destroyed by Hurricane Isabel in 2003. Today piers must be in front of owners' homes, not on the common ground, which is community property. (VC.)

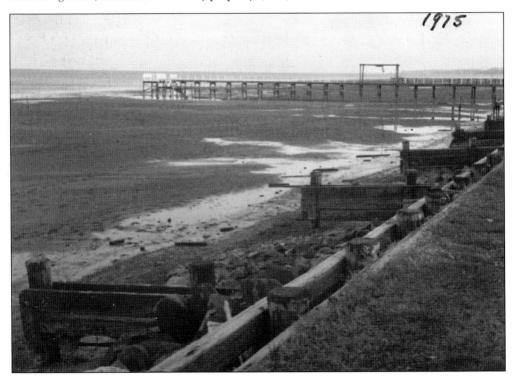

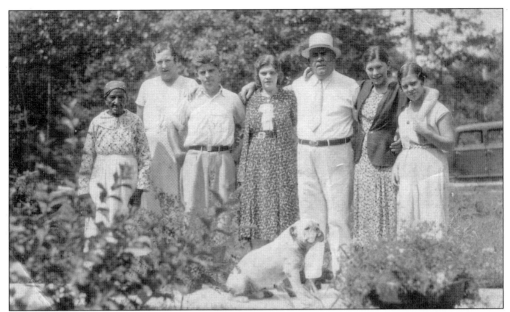

Bruce Lyons was the first police officer employed by the community and had a reputation for being rather formidable, especially in keeping the teenagers in line. He is shown above, third from right, with friends and family members in the 1930s and below, in uniform, also in the 1930s. He served until his retirement in 1945. The community continues to employ a peace officer who patrols on foot and by automobile, checking vacant houses and watching for trouble-makers. (JL.)

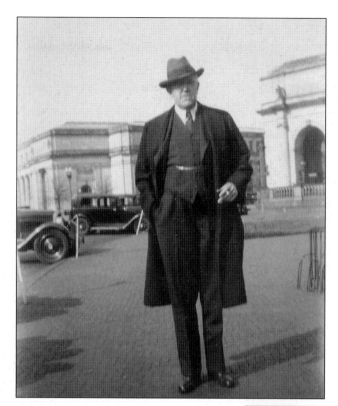

This image shows an affluent and confident Gibbs Baker Sr. in 1931 in front of Union Station in the District of Columbia. At that time, the Chesapeake Beach Railway was still bringing people out to the beach towns, and his development in North Beach Park was flourishing. (BD.)

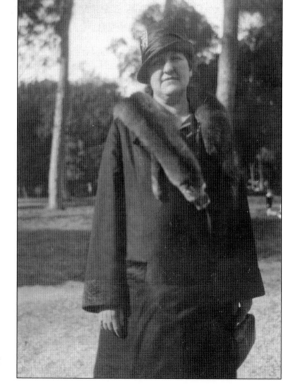

Caroline Baker is seen here in a spring or autumn photograph in the 1930s, very likely in the treed setting of her husband's North Beach Park development. She sports an extravagant hat and the fox-fur trim that was popular through the 1940s. (BD.)

This photograph was found in the family collection inherited by Bolling DeSouza, great-grandson of the community's founder, Gibbs Baker Sr. It was processed in October 1937 and is simply labeled "Beach." Because of the provenance and date, it seems very likely that this is a picture of the original Baker cottage on Myrtle Avenue near Holly Avenue. The cedar-shingle style is typical of the period, and the forested setting with porch would have suited a cottage over 100 yards from the bay in a clearing in the woods. Caroline Baker would have been 59 at the time, and her husband would live two more years. (BD.)

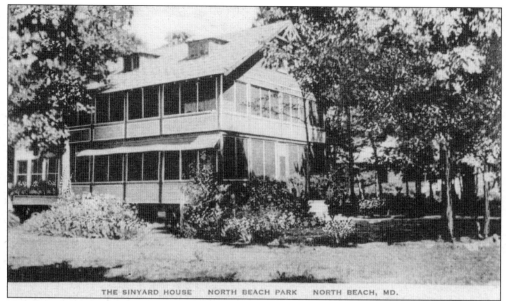

THE SINYARD HOUSE NORTH BEACH PARK NORTH BEACH, MD.

When Gibbs Baker developed North Beach Park, he stipulated that it should be residential only. There were two exceptions: a small marina to its south and Margaret Sinyard's bay-front home used as a restaurant and inn. In the early decades, visitors strolled up the unpaved road from North Beach for an elegant meal. This is a 1938 postcard of the Sinyard House. It has been used as a private home for over 60 years. (JP.)

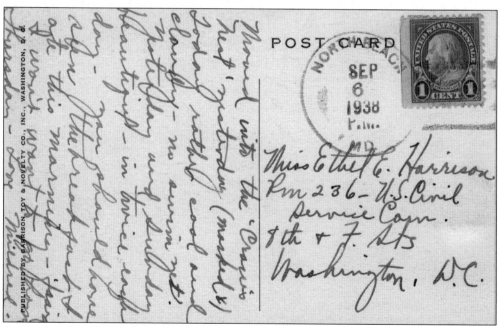

An unidentified "Mildred" took a late summer vacation in 1938 and sent this postcard back to her friend Ethel working in the city. The Crow's Nest was a small attic room at the top of the house with views of the bay and of the old trees around the houses. Swimming out front was still a pleasure—apparently the sea nettles were not a problem at that time. Mildred enjoyed a typical home-cooked breakfast. Sinyard's was famous for its fine cooking. (JP.)

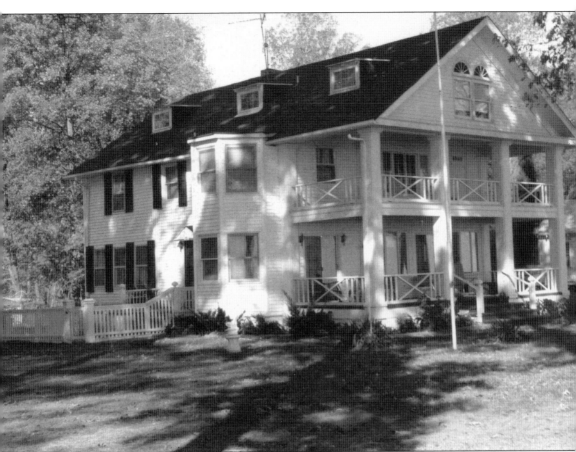

In 1925, what was to become the best known house in the community was mortgaged to Margaret Temple Hopkins and recorded as formerly part of Matthew Lyons's 309.25 farm acres purchased by Gibbs Baker and John W. Hayes for the North Beach Park subdivision. In 1927, Margaret V. Sinyard bought it and in 1930 purchased two nearby lots from the Bakers. The deed prohibited further commercial use "and other things." Sinyard operated her popular boardinghouse and restaurant here until 1944 and was known for her fried chicken and apple pie cooked on a black woodstove. Among the next owners were the Hillmans and the Sydows. Sometime after 1960, pillars from the John F. Kennedy presidential inauguration platform were added to the front of the house. John and Penny Williams owned it when this 1985 photograph was taken and lived there over 20 years. Bonnie Lefkowitz and William Culhane purchased the historic residence in 2003. (PW.)

Three-year-olds like Ann Parker were adept at getting out of their canoes in the early 1930s. Most residents owned a canoe for recreation, but in the 1933 storm, people who were stranded canoed the flooded road to reach the neighboring village of North Beach for supplies. (AP.)

After the great unnamed hurricane of 1933, Holland Point's beach was never the same. Here in 1938, Julie Ford, age 3, explores the day's gift of driftwood and the continually changing beach. (JF.)

Mary Young (above, around 1930) and Jenny Patane (right, 1937) show off their swimsuits as they enjoy the sand and surf at North Beach Park. Today Mary's three sons all own modern homes in a row on the bay front. Jenny's family had a cottage on Walnut Avenue, and her brother, Al, lived in his bay-front home at Linden Avenue for decades. (Above NY; right AP.)

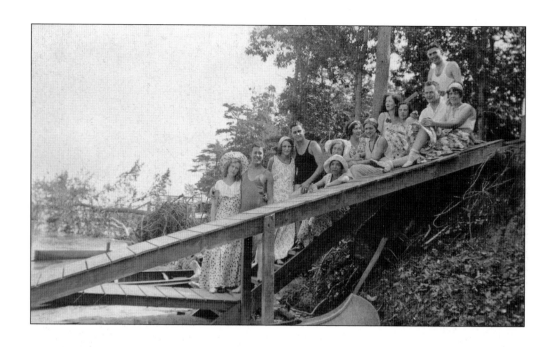

Among those gathered at the boat ramp leading from the Miller cottage to the beach are Gertrude Miller, Dorothy Reis, and J. Miles Miller. The occasion was a 1931 outing from the Simon and Young office in Washington, D.C., where Gertrude (above, seventh from left) worked. In the photograph of the group on the pier, she is the one in the center holding the little dog. Groups from the city were eager to come out on the Chesapeake Beach Railway or by motor car to spend a day playing on the private beaches of Holland Point—then still called North Beach Park. (MT.)

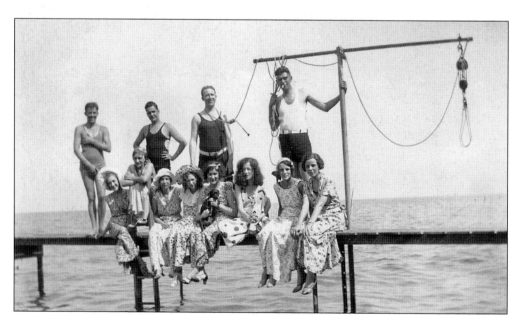

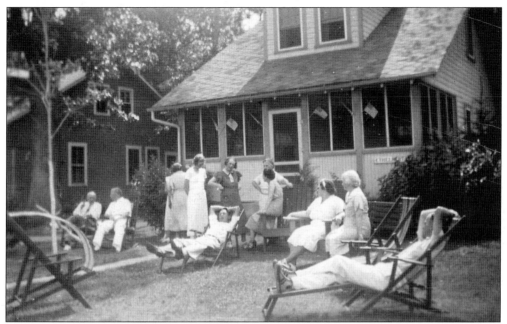

In 1934, the Burton family entertains neighborhood friends, the Fritz and White families, at a Fourth of July party near Filbert Avenue. Before air conditioning, people always entertained outdoors. The men in this group are wearing popular trousers called "white ducks"—the preferred attire of the men during this era. (BP.)

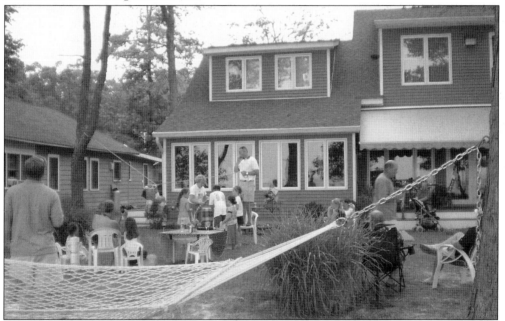

Generations of Holland Point homeowners have invited family and friends to spend the Fourth of July on the bay front. Celebrating at the home of Woody and Kathy Young in later years is no different, as children take turns swinging at a piñata while waiting to watch the fireworks displays from Chesapeake Beach and even from the Eastern Shore. Among those playing are the McGrath, Kleb, and Schwab children. (KY.)

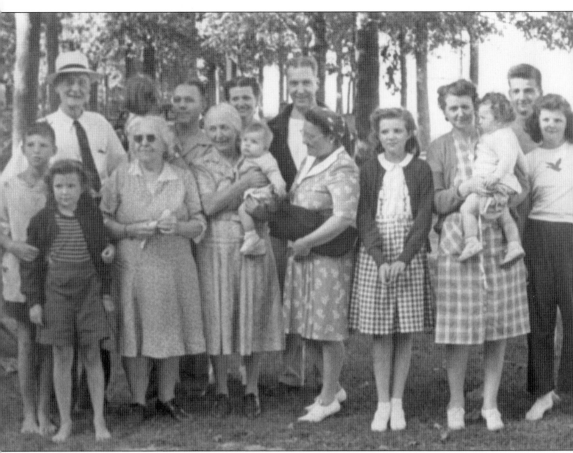

Having an outing on the front between Elm and Cherry Streets in 1946 are three next-door families and friends. From left to right are (first row) John Hartke III, Genevieve Sansousey, Catherine Hartke, Bridgett Doody (holding Bliss Sansousey), Mrs. James Hartke, Mary Jean Stock, Mary D. Stock (holding Mary Hartke—later Breslin), and Ellen Hartke—later Bettencourt; (second row) John Hartke Sr., James Hartke (holding daughter Ellen), unidentified woman, John Hartke II, and Leo Stock. (JTB.)

Four

WAR AND PEACE
THE 1940S AND 1950S

By 1940, new generations were growing up with their families at the bay. Many friendships remain today that started then. Piers over the shallow water were used for swimming and even careful diving. Every evening, people would gather on them to talk and enjoy the water and sky. Summer romances flourished, many of them culminating in marriages. Young people stayed near home in these decades, but they could walk a mile or two down to North Beach for entertainment. There they had good times at Uncle Billie's Pier, a club, the penny arcade, and other attractions. Slot machines were legal there between 1948 and 1968.

Walnut Avenue was paved by the early 1940s. In 1948, it was opened north to connect with Route 2 through Old Colony Road after Joe Rose's development of Rose Haven. Presidents of the citizens association included Wootton Young in the 1940s and Alex Breslin in the 1950s. At tax sales, Sceno Investment Company purchased the majority of the remaining undeveloped property. In 1946, Robert Cason, last owner of Holland Point Realty, sold the remaining lots to Sceno.

On the bay front, people took much pleasure in watching the Wilson Line steamer pass on the way from Baltimore to the renamed Seaside Park in Chesapeake Beach, making that trip daily every summer until the United States entered World War II. After the attack on Pearl Harbor, boating came almost to a standstill. A large local yacht was loaned to the navy for defense. Because of gas rationing, people with major homes in the city were allotted only two trips a year to their cottages. Many families therefore spent the entire summer at the seaside. Most of the women and children walked or canoed to North Beach for food and shopping. The young men entered the service, and it was a grand day when the war ended and all were able to come freely back to the bay. Boat hoists were built then, water-skiing became popular, the men went fishing, and Maryland blue crabs were plentiful.

However, life on the bay was not without trouble. The major local tragedy of the 1950s was the dramatic wreck of the pleasure schooner the *Levin J. Marvel* while Hurricane Connie lashed Holland Point's shore at night. When 14 passengers drowned, newspapers from coast to coast carried the sad story. The bay could be as powerful as it was beautiful.

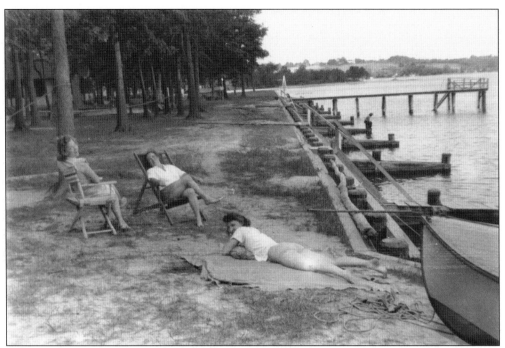

With the beach gone in 1941, the Zimmerman ladies sun themselves on the sandy lawn above the water's edge. Seen from left to right are Ruth, her mother, Bertha, and her sister-in-law, Dorothy. This photograph shows the then-sturdy seawall protected by a row of 20-foot-long jetties. The view looks north toward Herring Bay and the future site of Joe Rose's development of Rose Haven. Today it includes a resort and major marina, Herrington Harbour South. (RH.)

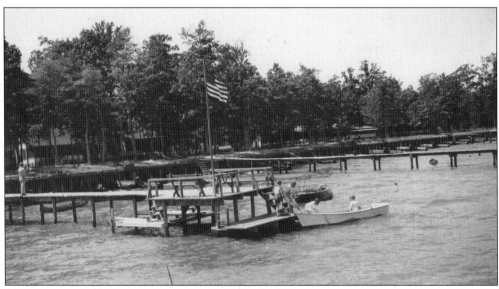

In the summer of 1940, people with piers freely used them to access motorboats as well as the older rowboats. Two boats are pictured getting ready for fast rides on the bay. In this summer before the start of World War II, no one knew that it would be the last season for several years in which they could use gas-powered boats before wartime gas rationing. (MT.)

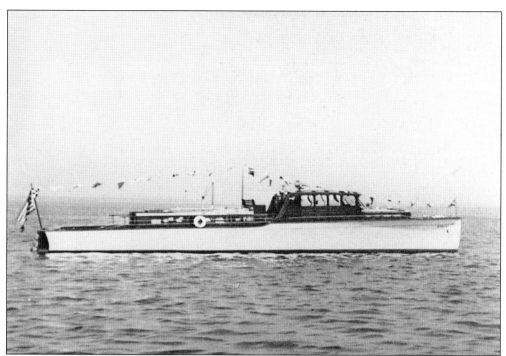

The *Marcia* was a 62.5-foot twin-screw yacht belonging to the family of Mary and John Meenehan Sr., who were early residents. They had nine children who used the yacht when at Holland Point. John Meenehan Jr. especially relished sailing the *Marcia* on the Chesapeake. During World War II, he served as a naval officer and turned his ship over to the federal government, which used it to patrol the Potomac River and guard the capital city against enemy invasion. John Jr. managed the Meenehan family hardware stores in the District for several decades. (SL.)

There has always been lots of "horsing around" during summers in the Park. Walter Wondrack and Al Patane are shown here on the Wondracks' pier around 1946 having fun with a crab net. Al does not seem to mind being Walter's big catch. (AP.)

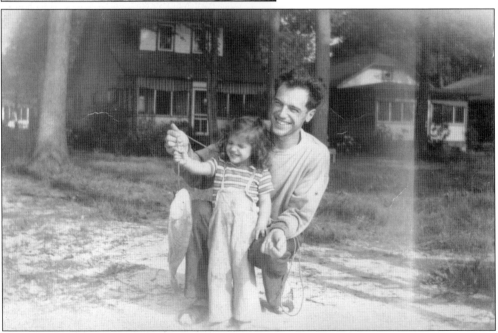

Kathy Cheston admires a fine fish caught by her father, Finley Cheston, in the summer of 1946 in front of the Moreland cottage at Juniper and Walnut Avenues. Paul and Mabel Moreland were Kathy's grandparents and had been at this cottage since it was built in the early 1920s, making them one of the founding families. (KY.)

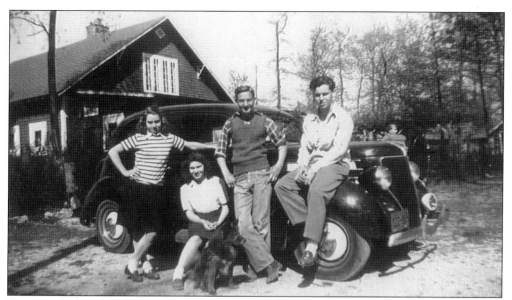

The spring of 1945 finds, from left to right, Dolly, Dolores, and Cornelius "Sonny" Link Jr. with cousin Jack Watterson leaning against Jack's 1937 Ford parked in the Links' driveway. World War II would be over shortly, and gas for cars like these would slowly become more readily available, making trips to cottages more feasible. In the background is the Creightons' house, which would burn down in 1961. (DT.)

Cornelius Link Sr. and wife Martha pose in the backyard of their new cottage on the bay front in the summer of 1945. The Links had owned a house in Randall Cliffs several miles to the south. After it was taken by the federal government for the Naval Research Laboratory navy installation during World War II, the Link family relocated to Holland Point in 1945. (DT.)

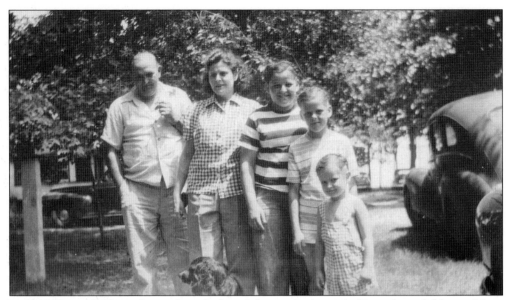

In 1946, Kenneth Kennedy stands with, from left to right, his wife, Vera, their children—Mitzi, Betty, and Carolyn—and family pet spaniel, Mikey, in front of their cottage at Cherry and Walnut Avenues. The family spent all the warm months there, mostly fishing and touring on the Chesapeake in their bay cruiser. The original cottage has been replaced with a two-story house. Betty Kennedy Burley lives in nearby Owings. (BB.)

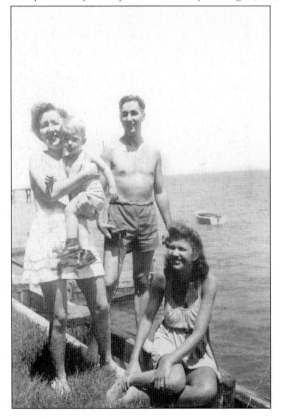

Sally Meenehan Hilleary holds her son, Michael, while standing next to her brother Frank Meenehan and his wife, Mary. A neighbor's motorboat is anchored in the water behind them. Before boat hoists were built, it was the usual practice to moor boats a little off shore. Many of these boats floated away during storms. After the storms, young people sought them out up and down the shore. (SL.)

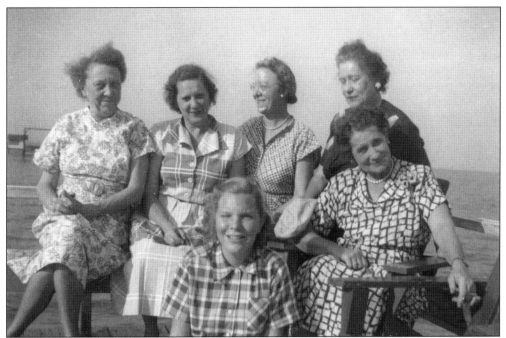

Sitting on the pier in the latter 1940s are, from left to right, (first row) Nancy Wurtz and Magdaline Raulin; (second row) Pluma Volland, Mildred Wurtz, Ann Barnett, and Gertrude Miller. Mildred, Gertrude, and Magdaline were sisters whose maiden names were Volland. They, as well as their brother, Dave, built cottages beside each other in Holland Point. (MT.)

Starting in the 1920s, the extended Volland family built four side-by-side homes on the bay front between Locust and Magnolia Avenues. The Volland daughters married into the Miller, Wurtz, and Raulin families and along with their brother all remained in the community. The house on the right was rebuilt after a fire in 1982 destroyed the original structure. (JP.)

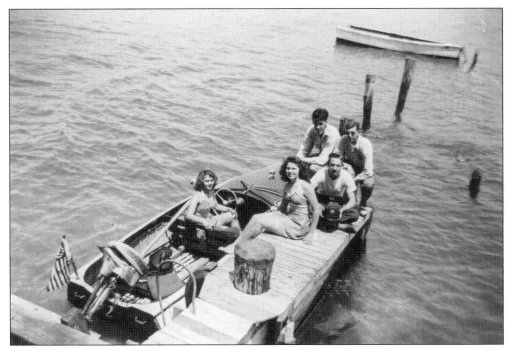

In the summer of 1947, Dolores Link sits in the family's outboard run-about. Dolly and Sonny Link pose with two friends behind them on the jetty in front of the Links' cottage near the Point. Jetties were often modified for use as docks for boats, fishing, and swimming. (DT.)

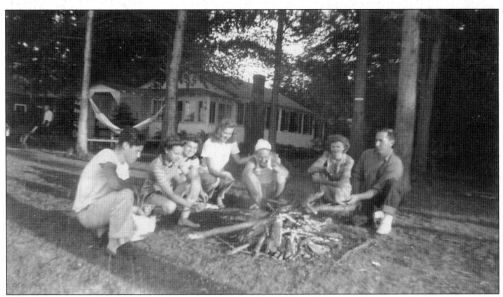

Before the great storm of 1933, cookouts were usually held on the beach. This 1946 cookout for family and friends took place on the bay front near the Links' cottage. From left to right are Jack Watterson, Dolly Link, Dolores Link, an unidentified friend, Sonny Link, and Alma and Buck Anderson. Hammocks, such as the one slung between two trees in the background, are still popular in the Park. (DT.)

Although it was not unusual in the 1940s to catch good-sized rockfish in the middle of the Chesapeake Bay, to land a striped bass this size casting from a pier was rare. Marion Funk caught this one from the nearby pier in the summer of 1949. She and her husband, Earl, were renting a tiny cottage on the bay that year and spent many a fine day fishing. (JB.)

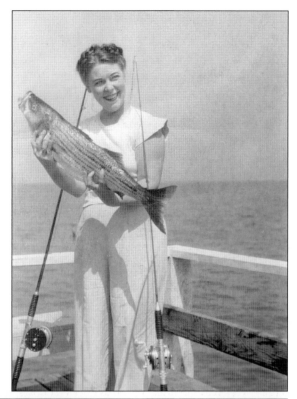

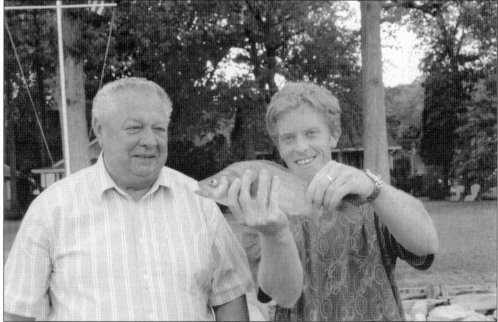

Showing that there are still big fish just off shore, Ben Hald, on the left, and Greg Pulse pose with a large perch Greg caught off the end of the pier in 2007. Perch and spot are popular small fish that are very good eating. Greg Pulse is the son of residents Lester and Jean Pulse. Hald and his wife, Norma, live next door to the Pulses. (JP.)

An unusually low tide in the winter of 1949 bares the old beach again, half covered with snow on ice. Walter Wondrack is looking at the exposed jetties all along the shore. (CW.)

Very low tides occur several times during an oyster season. Here Roland Dixon hand digs for oysters hiding in the sands of Holland Point in 1949. It is still possible to gather oysters in this manner, but their population is rapidly dwindling. Some residents used to cultivate oysters in their garages by keeping them wet and feeding them cornmeal. (CW.)

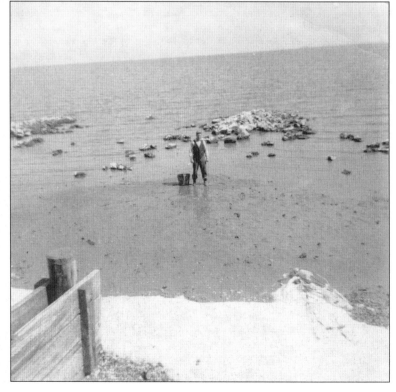

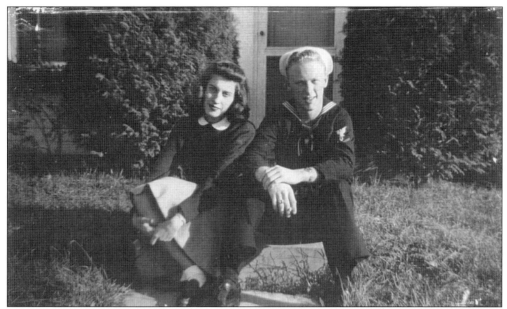

Below, friends and family gathered in October 2002 to honor Charles "Butch" Bates, who had died that February. When he first came to the Park in 1942, he vowed he would never leave this beautiful community, and the only major exception he made was to serve in the U.S. Navy during World War II. In 1944, he married Janet Buckingham, and they visited her family's bay-front cottage until 1972, when they inherited it. He lived there the rest of his life, including during his career as a mechanical engineer. They are shown above in 1944 as very young newlyweds when he was on leave from the navy. Their marriage lasted 58 years and produced two children, four grandchildren, and five great-grandchildren. Some of those attending his memorial service had traveled from afar and are pictured here at the bay front near the Bates cottage. (Above JB; below JM.)

Marjorie "Marge" Wondrack shows the high tide almost touching the family pier in the 1950s. Behind her is a tool shed atop the pier. This was unusual, as the sea winds tended to wreck such structures. (CW.)

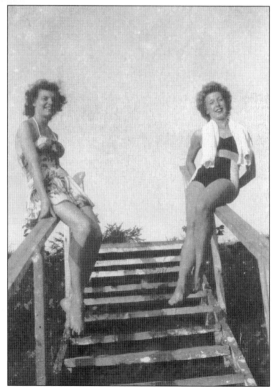

Betty Quigley (right) and friend were two typical 1950 bathing beauties of the community. Quigley taught tap dance locally for decades after her stint as a member of New York City's famed Rockettes. (BQ.)

Julie Ford, standing between jetties in 1951, bravely holds the top of a "sea nettle," the local term for the stinging jellyfish, taking care to avoid touching the stinging tentacles. The protective jetties, when built in 1937, were expected to last a long time. Children would run and jump over them. The sea level has risen through the years, and today the jetties are hardly visible. (JF.)

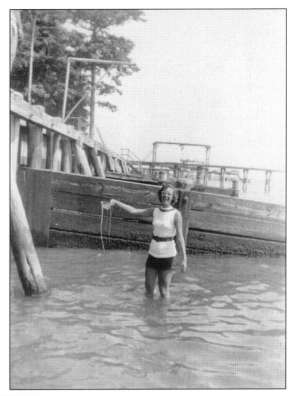

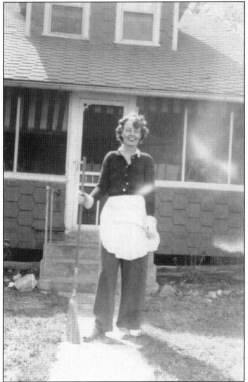

Elizabeth Fritz was a community activist who served as the association's corresponding secretary for many years. Of Dutch background, she is seen here in the 1950s sweeping clean the walk in front of her house. For many years, she took charge of the bake sales at the annual October oyster roasts and was known to pray for, and receive, fine weather for these events. The 2004 oyster roast was dedicated to Elizabeth. (MK.)

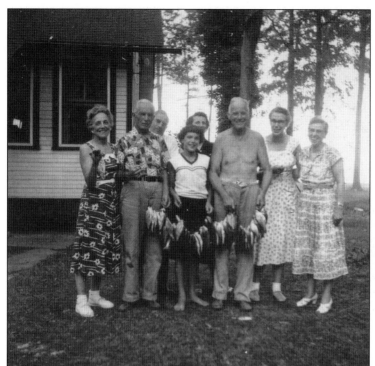

Paul Moreland displays his catch of perch and spot while posing with his extended family in front of the Moreland cottage in 1954. From left to right are Katleen and Harvey Cheston, an unidentified visitor, Kathy Cheston, Miriam Moreland Cheston, Paul Moreland, Mabel Moreland, and an unidentified visitor. Today Kathy Cheston Young resides in the renovated house. (KY.)

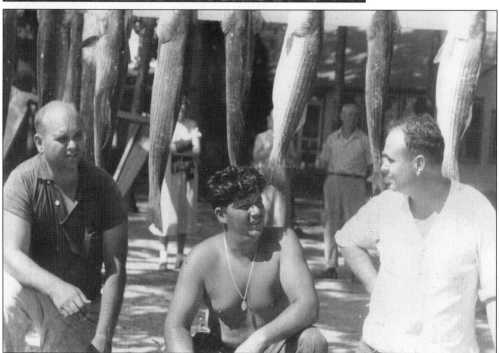

From left to right, Lyle Wyman, Domenick Panzone, and Lehr Wyman display their 1951 catch of large rockfish. Such a haul generally was made by means of motorboat trips to secret fishing holes in the bay rather than from piers. Maryland began regulating striped bass harvests in the early 1920s, but the low dip in their population came in the 1970–2006 period. (CW.)

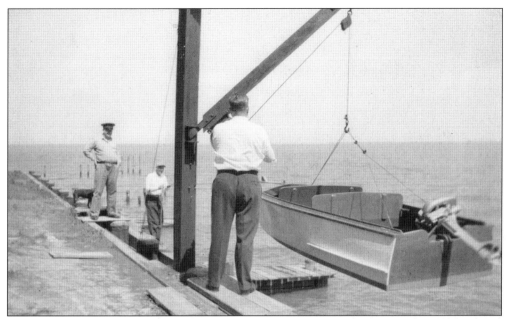

After the seawall was built in the late 1930s, beach access for boats ended. Davit boat hoists such as this one, in action in 1950, became necessary for hauling boats completely out of the water. Although it looks easy to work, during rough weather, it could be very tricky. When rocks were added in the late 1960s, these seawall hoists became obsolete. Now boat lifts are built at the ends of piers. (RH.)

This elaborate boat hoist was built on the land in front of the Federline cottage near Linden Avenue. It was one of many kinds constructed after the beach was destroyed. There were a few like this one built on the common property. Marion Federline is the gentleman standing in the boat in 1956. (HL.)

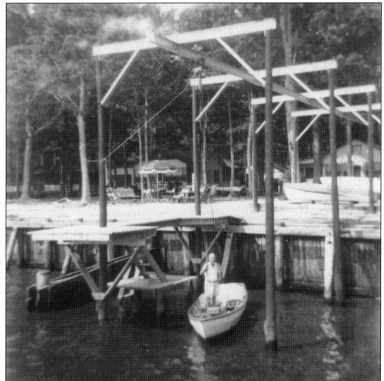

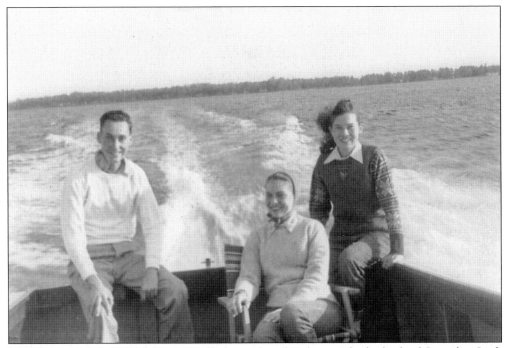

John Cannon and the Link sisters, Dolly (center) and Dolores, ride the back of Cornelius Link Jr.'s day cruiser. He built it himself in the backyard of the Link family home at the bay front and Myrtle Avenue. (DT.)

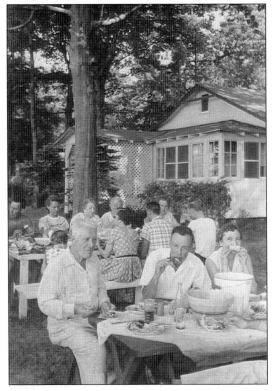

A cookout in 1958 finds, from left to right, Cornelius Link Sr. and Jack and Mary Cannon sitting at the front table. Behind them are friends and family. Crabs and freshly caught fish were, and still are, the preferred fare at these get-togethers. (DT.)

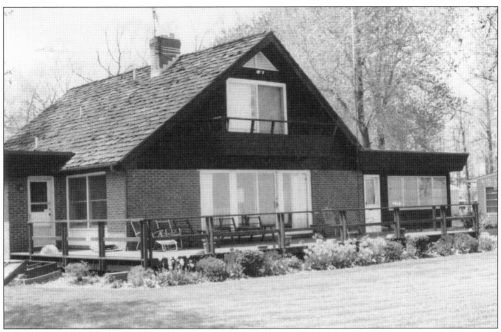

The relatively low-slung cottage, built around 1960 between Myrtle and Maple Avenues, belonged to Lester and Dolly Thomas for several years. It was close to the Point near the north end of the community and fronted on Herring Bay with views of the Chesapeake to the south. Douglas "Doug" and Theresa "Terri" Sisk purchased it in 1999. In 2006, they completely renovated it by adding two levels and porches for all floors. The inside of the downstairs retains something of the charm of the original cottage. The Sisks own an automotive body shop in nearby Owings, which their daughters help manage. Family members have held several offices in the Holland Point Citizens Association. (Above DT; below JP.)

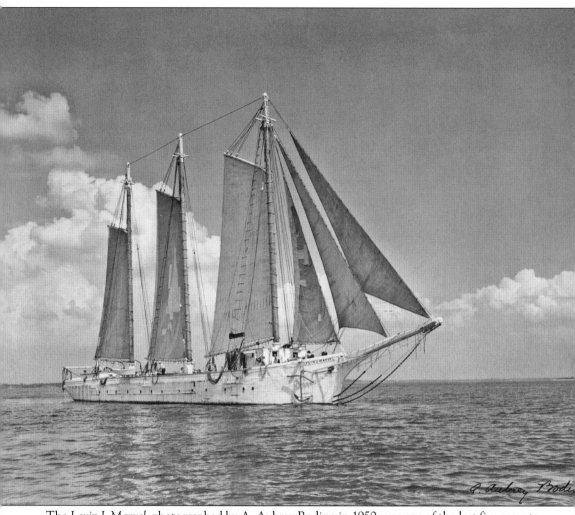

The *Levin J. Marvel*, photographed by A. Aubrey Bodine in 1950, was one of the last five rams to sail the bay. These were three-masted wooden cargo schooners. Novice skipper John Meckling had the old *Marvel* refurbished as a tourist cruise ship and set to sea. Inexperienced, unlicensed, and under-staffed, Meckling was no match for Hurricane Connie in 1955. The storm changed course while he tried to harbor his vessel in Herring Bay the night of August 12, and the ship smashed to pieces. Of the 23 passengers en route to Annapolis after a five-day cruise, 14 drowned. Bay-front residents, volunteers from the North Beach Fire Department, and heroes William K. MacWilliams and George Kellam rescued nine passengers and the four crew members. Making repeated trips with a small borrowed boat, they saved some who were clinging to an offshore duck-blind in the raging storm and plucked others directly from the water. The newspapers reported the accident happened off North Beach, but old-timers remember it happened off Holland Point. (AB; Copyright © Jennifer B. Bodine, courtesy of www.AAubreyBodine.com.)

Five

ROCK AND ROLL
THE 1960S AND 1970S

Holland Point was still a summer vacation place in the 1960s, and few people were full-time residents. The William Bowden family, however, intended to be permanent residents. Their home at Myrtle and Bayfront Avenues was under renovation when in April 1961 it caught fire during the night. The entire extended family perished, and the house was completely destroyed. This was the worst tragedy the Park had experienced.

The first oyster roast in the new association building was held in November 1962. There had been no permanent community meeting place since the loss of the original clubhouse in the 1930s. The major landowner, Sceno Investment Company, donated four lots across from the old building for the new association home.

In the late 1960s, a rock program was implemented to shore up the deteriorating seawall. Howard Cooper, then president of the association, headed the rock committee. Julia Young arranged to obtain the first large rocks from the construction of the D.C. Metro System. Richard Casey and Bernie Loveless worked on the riprap wall in the 1970s, and Loveless continued to head the renewal project into the 1990s. A moratorium on building was imposed upon the community because of poor percolation of the soil and failing septic systems. This kept the Park unchanged for scores of years.

The annual Christmas party started with the 50th anniversary of the North Beach Park Citizens Association in 1977. Two years later, the name would be changed to the Holland Point Citizens Association. An unsubstantiated story related in 1939 had told of a ship sailing from Fairhaven, Holland, in the 1700s; those Dutch people supposedly named Holland Point and also Herring Bay for its abundant silvery fish. But Holland Point Farm and Holland Point were named for their 17th-century owner, Francis Holland. Thus a historic name was reclaimed.

In the 1970s, more people with children were moving into the area permanently. Residents Ruth Marx and Rosalee Russell helped form the Holland Point Youth Group, which sponsored parties and activities for children, including those from Rose Haven, the neighborhood to the north. Many changes had occurred between 1960 and 1980, and now the Park was indeed becoming not only a place to play but also a permanent residential community.

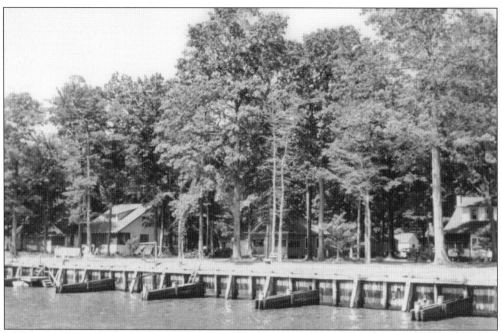

This 1955 view from the end of a pier shows a section of the original seawall. Had the jetties been longer, more of the beach might have been saved. The wall was adequate to protect the front from further erosion until the late 1960s, when the first shipment of rocks was financed and hauled in. (JB.)

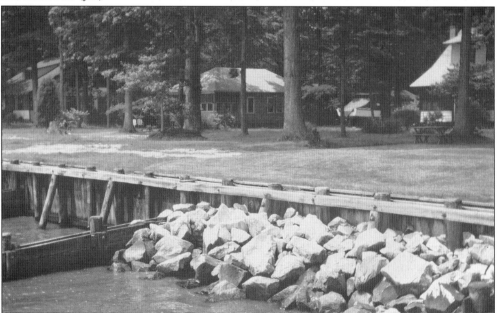

Between 1967 and 1976, large rocks were placed up against the old, deteriorating wooden seawall to shore it up. This picture shows a section of the old wall in block 10, before and after the first rocks arrived. In 2007, a new team, including Woody Young (grandson of Wootton Young, who pioneered the seawall), was again planning to redesign and rebuild the seawall to improve its strength and endurance. (JB.)

Shifts on the floor of the bay often cause what local people call "phenomenals." These generally stretched for good distances as long, straight swells or waves on the bay. Occasionally large boats may cause the same thing. This has always been a beautiful sight and brings people out to watch, such as Eric Hohnadel here observing one such wave in 1969. (JB.)

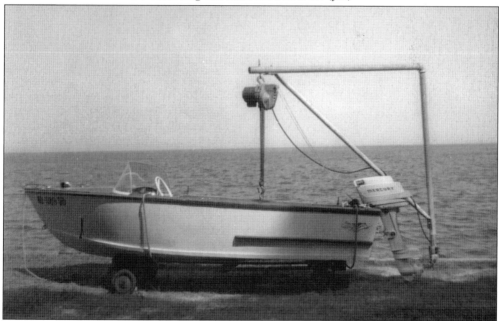

After the seawall's construction, boat hoists were needed so residents could lower their boats into the water. Butch Bates built this one in 1960 for his boat, the *Titanic*. He affixed straps around the boat near the stern and behind the windshield, connected by a line to which he attached the hoist, lifting the boat from the land trailer, over the seawall, and down into the water. (JB.)

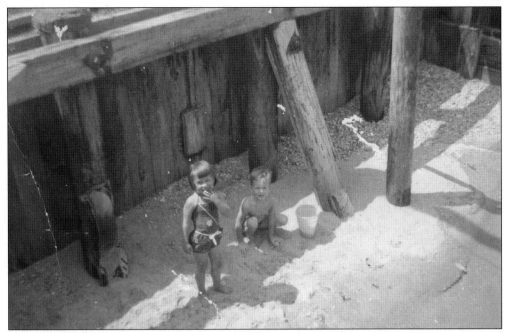

Occasionally Holland Point's beaches would reappear, teasing with the possibility of a return to the pre-1933 days. Here Donna and Douglas Lidie make the most of the brief return of the beach in August 1965. With access via stairs or ramps, children would gather mussel and oyster shells pushed to shore by tides. The photograph also provides a view of the functioning wooden seawall and its supports. (HL.)

In 1961, Caroline Kennedy and her brother Kenneth Jr. look for beach glass and fossilized sharks' teeth on this small beach immediately south of Holland Point. The seawall in the background marks the end of Holland Point, a short walk from their family cottage. Horseshoe crabs, bay grasses, driftwood, and oyster and mussel shells have washed up onto this beach for eons. (BB.)

Many types of piers and docks have played a part in the life of those who swim and fish around Holland Point. In this 1960s photograph, neighborhood children wait to jump into the water from the lowest level of the Allen family pier, with Morris and Judge Allen watching from the top deck. (RD.)

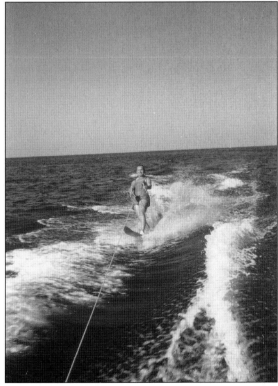

Dolly Link shows her skills at slalom water-skiing. She follows the Link family motorboat out in Herring Bay in 1963. Water-skiing was one of the ways people played and stayed cool in summertime. In the 21st century's Jet Ski age, such energetic, family water sports are seen less frequently. (DT.)

This picture of water skiers in 1955 shows the house in the background that was owned by Dr. Creighton and family at the time. It was built on several lots on a large parcel of land on the Herring Bay side of the point shown in the picture. The next and final owners were the William Bowden family. (DT.)

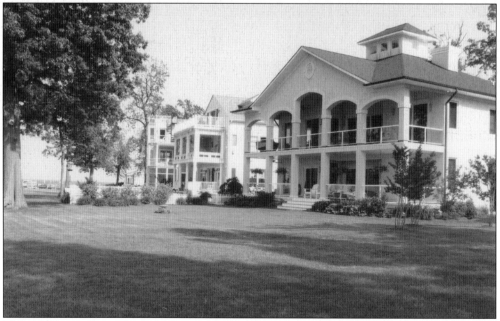

This 2007 view shows the property on which the burned Creighton/Bowden house stood. The land was a meadow for almost 40 years while lawyers untangled inheritance issues. The declared heirs quickly sold the lots in the 1990s. Kip Suss built the house on the right, one of many large new homes in Holland Point. Steve and Linda Watson soon built the next home, and Frank and Connie Dunkerson the third one. (JP.)

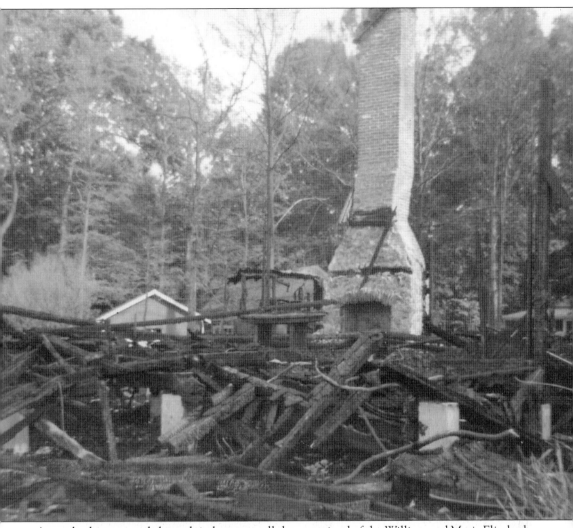

A stately chimney and charred timbers were all that remained of the William and Marie Elizabeth Bowden family house (formally Dr. Creighton's) after the raging fire that destroyed this home the night of April 23, 1961. This, the largest house in the community, was being renovated at the time. Marie Bowden was a former New York actress who, at one time, had a part in the Broadway play *Oklahoma*. Her mother, Xenia Farr, also lived in the home, along with the six Bowden children. All nine members of the extended Bowden family perished in the fire. Marie telephoned in desperation from inside the inferno, "I can't hold on much longer," but the Annapolis telephone operator could not trace the address, and the line went dead. Indeed, the houses were not numbered at the time. Neighbors were helpless to assist. This was the Holland Point tragedy of the decade. (DT.)

Al Patane sits with children Rosemarie and Tony on a swing near their house at Linden and Walnut Avenues in 1960. Many residents hang such swings from the trees that always have graced the Holland Point bay front. The forest here was so abundant at the dawn of the 20th century, before people settled here, that a nearby lumber mill timbered it for the valuable wood. (RD.)

Standing on one of the piers on the Holland Point bay front in 1969 are Rosemarie Patane and Eric Hohnadel. They are two of quite a large group of young people who grew up spending their summers together swimming, boating, and hanging out at the "Sugar Shack," an informal clubhouse for teens. Soon after this picture was taken, Eric joined the navy. (RD.)

Julie Young appears apprehensive as her uncle Raymond Young shows her two very nice rockfish caught in 1973. Rockfish are also known as striped bass and are easily identified by the stripes going full-length down their long bodies. (JB.)

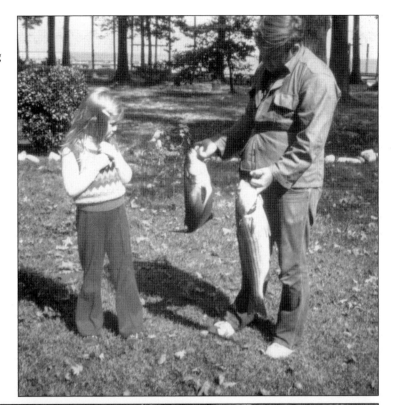

Before air-conditioning, neighbors often found themselves outside, such as these friends and families in 1978 joining in an open-air bay-front cocktail circle. From left to right are (first row) Butch Bates, Gene and Mary Young, and Nancy Young; (second row) Jean and Steve Bullard, Raymond Young, Kathy Young holding nephew Patrick Young, Janet Bates, and Miriam Cheston. (KY.)

In 1962, the community built a new home for the North Beach Park Citizens Association. They held the first oyster roast in the new building that November. The Park had not had its own clubhouse since 1934. Meetings had been held in homes or hotels in Washington, D.C. In 1968, the association acquired the triangle of property in front of the building, providing more space for events and parking. (JP.)

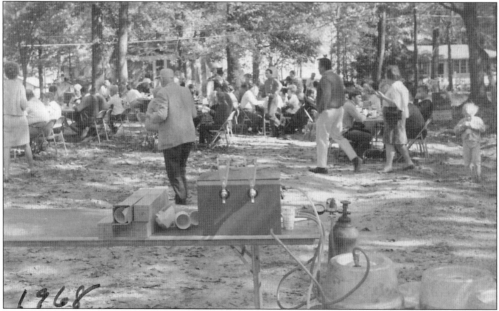

One of the first October oyster roasts in the current association building was a casual event with self-serve beer free with the price of admission. Before 1962, the annual oyster roasts were held at the old Rod-n-Reel restaurant in Chesapeake Beach, in Rose Haven, or at residents' homes. Chesapeake oysters have been relished since Colonial times, then so plentiful that farmers also used them as fertilizer. (VC.)

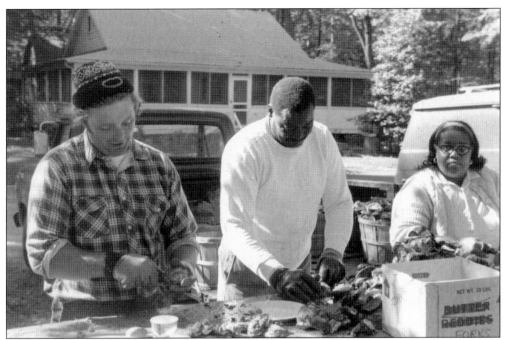

Loretta Willet, far right, and unidentified coworkers, shown at the 1972 oyster roast, were the oyster shuckers for many years. In the background can be seen the building that originally was the first association clubhouse (until 1934), erected in 1928 and subsequently renovated as a private residence. (VC.)

At the 1976 oyster roast, from left to right, Dolly Link Thomas, Les Thomas, and Dorothy Loveless were among those enjoying "padded" oysters, ham, coleslaw, baked beans, potato salad, and home-baked desserts. The women made those padded oysters in a labor-intensive process, dipping gallons of oysters three times each in a milk-and-egg mixture and then in a seasoned flour-and-cornmeal mixture, setting them to dry on trays, and then deep frying them. (DT.)

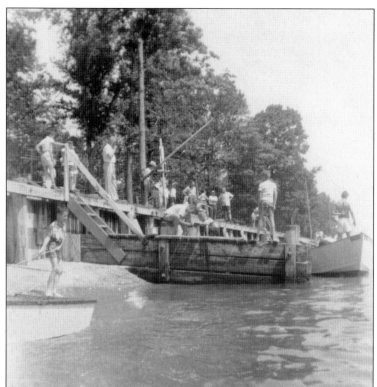

Kenneth Kennedy and friends built a boat hoist on the bay near Cherry Avenue. It was a neighborhood project and included, among others, daughter Carolyn, Kenneth Jr., Robert Small, and the usual group of bystanders seen at any outdoor event at Holland Point. (BB.)

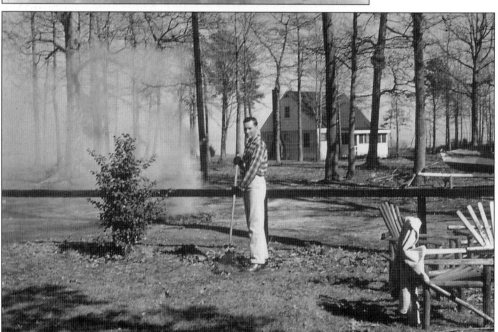

John "Bus" Cannon rakes leaves at his cottage at Myrtle and Walnut Avenues in March 1962. This was an annual ritual for part-time residents during which they prepared their homes for summer use. More often than not, the fall and winter months littered their properties with leaves and tree limbs, not to mention the vigorous growth of poison ivy and weeds to be removed. (DT.)

Finley Cheston (on ladder) built this innovative boat hoist attached to the seawall in the 1970s. Eric Hohnadel is working with Finley, Bob Blase is in the water, and Gene Young Jr. is on the platform. This hoist was constructed on the side lot of the Cheston cottage and laboriously taken to the water by Finley and helping neighbors. The picture below shows that new boat hoist several years later when it was destroyed by a storm pounding at the seawall. (JB.)

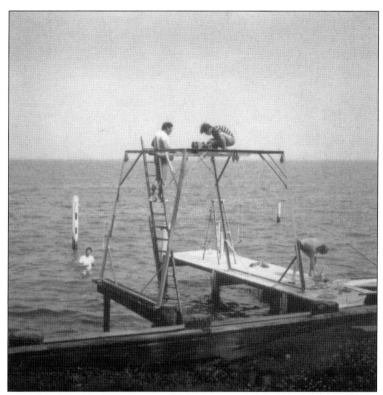

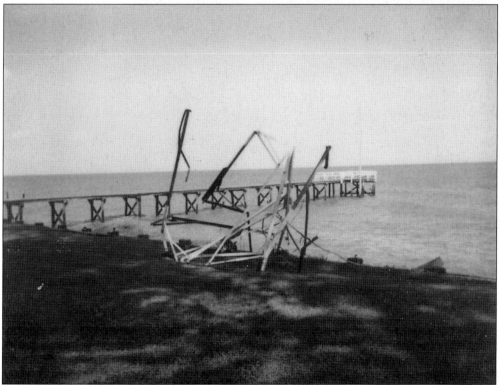

Here, from left to right, are the Quigleys, Michael, Patrick, and Richard (Ricky), Elizabeth, and Joseph "Bumps" Jr., in front of Mildred and Joseph Sr.'s house on Juniper and Walnut Avenues. Soon they would buy their own cottage, two blocks down on Walnut, and also add to their family a baby girl, Linda Jo. Another generation follows parents in finding homes nearby on Holland Point, enriching extended family life. (BQ.)

Joe and Mildred Quigley have an informal meal in their house near Juniper in the late 1960s. They bought it in the 1950s and shared many summers there with children "Bumps" and Helen. After retirement, they moved to the cottage and became active in the citizens association. Joe Sr. initiated winter bingo parties and managed the "Ship of Cheer" fund-raiser at the fall oyster roasts—a tradition carried on by his son and grandson. (BQ.)

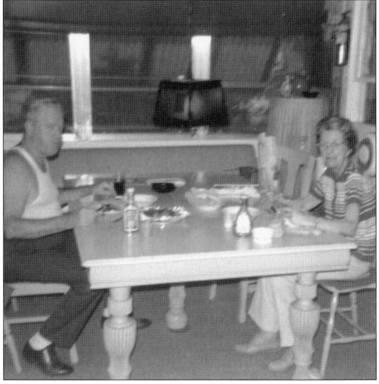

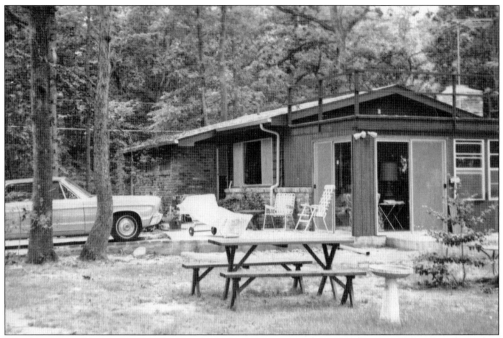

This house on the corner of Walnut and Maple Avenues was owned by Paul and Margaret "Maggie" Knowles in 1967, when the photograph above was made. The house was razed after completion of the public sewer system in the late 1990s again permitted construction projects following decades during which building new houses was not allowed. Pat Knowles Tait inherited the original home and, with her husband, Robert "Bob" Tait, built the large, modern home below in its place where they now live as full-time residents. They are both active members of the community through the Holland Point Citizens Association. (PT.)

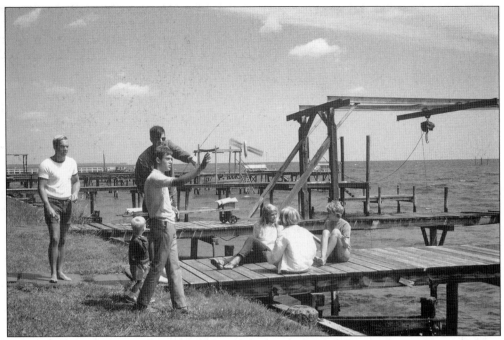

On a lovely, cool summer day in 1968, from left to right, Woody Young, Jimmy Bryan and son Robbie with Eric Hohnadel talk with Debbie Lidie, Nancy Bates, and Helen Bryan on the pier. This was one of those perfect days, quite breezy and with plenty of sun. During storms, boats on the hoists, such as the one in the background, often had to be rescued from high winds. (JB.)

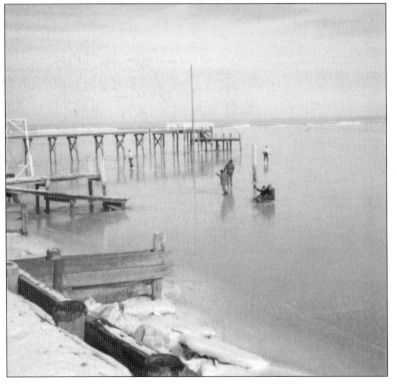

In the unusual winter of 1977, the ice on the bay was strong enough for neighborhood children to play "walk on the water" and sled. The ice-breakers are busy out in the shipping channel clearing the deeper middle of the bay. (JB.)

Shown from left to right are (first row) Debbie Lidie, Rosemary Patane, and Geraldine Mabry; (second row) Joyce Myers, David Lidie, and an unidentified friend gathering for a party in 1968 at the Sugar Shack. This is a little house on the alley behind the Taggarts' residence. The teenagers named their clubhouse after the popular 1960s song performed by Jimmy Gilmer and the Fireballs. After this group of teenagers left, others came along to use their hideaway. (NY.)

This is a 1980s photograph of a miniature cottage built in the 1940s by Gertrude Wand and her brother Dave Volland, two of four siblings who were also neighbors on the bay front. This is the tiny cottage local youths dubbed the Sugar Shack in the late 1960s. It is now owned by the John and Miles Taggart family. Miles is the daughter of Gertrude Miller Wand. (MT.)

$300 REWARD

for information leading to the arrest and conviction of a person or persons found guilty of breaking and entering houses in North Beach Park, Md.

Contact William Clark, Special Officer, North Beach Park 301-257-6940 or if mailed, to President, North Beach Park Citizens Asso., Box 232, North Beach, Md. 20831.

ALL INFORMATION CONFIDENTIAL.

From the earliest days, the citizens association of North Beach Park/Holland Point employed a part-time special police officer to patrol the lanes, roads, and waterfront of the private community. This 1970s poster may well have led to the arrest of any culprits. William "Bill" Clark was the community peace officer at the time. (HPCA.)

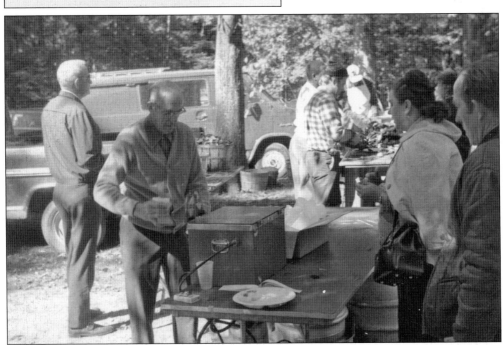

Bill Clark is shown here getting a drink at the 1972 oyster roast. Behind him, among others, is Dick Casey, one of the presidents of the association. Bill and his wife, Dorothy, lived in a house at Linden and Bayfront Avenues when Bill was the Holland Point police officer, patrolling the community by car and on foot. Checking their properties often, the officer is especially important to part-time residents. (VC.)

At the farewell party for Howard Cooper and family in 1972, Elizabeth Fritz talks to Howard. He was the association president for several years during the 1960s. As the old seawall began to give way to age and water damage, Howard headed a group starting the program to replace the wall with rock, and this program continues today. (VC.)

Jack Power, Margaret O'Malley, and Virginia Casey (right) attend a get-together in December 1977 commemorating the 50th anniversary of the Holland Point Citizens Association. This turned into the annual Holland Point Christmas celebration. For many years in the 1990s, Jack Power used humor and bravado to auction off odd donated items, with the proceeds going to Children's Hospital in Washington. (VC.)

95

Suzanne Liggett commemorates the big snowstorm of 1976. She and her husband, Malcolm, helped dig out the nearby Clark family as well as their own cottage. The Liggetts came from the city that day just to check the cottage but ended up being totally snowed in. With electric power out for several days, the wood stove in their small "Building B" provided for heat and primitive food preparation. (SLL.)

Linden Cottage on Walnut Avenue in 1979 was the original 1929 cottage plus side extension, metal siding, and front awning. The Liggetts enjoyed it largely as a weekend haven for 20 years until their retirement to Florida in 1993. The present owners, Adrian and Alice Birney, have left it much the same—except for the mass of bushes and trees buffering it from the road traffic. (SLL.)

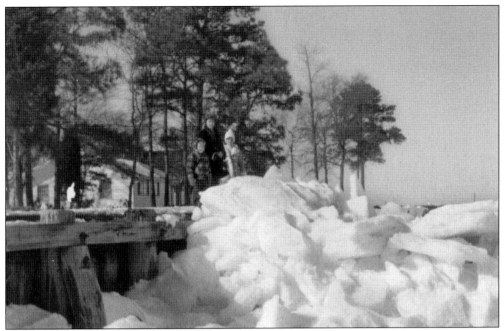

Pictured from left to right are Paula Tait, Pat Tait, and Michael Tait (behind the mountain of snow and ice) during the 1979 snowstorm, when ice and snow piled up against and above the old seawall. Harsh weather such as this has contributed to the decay of the wooden wall throughout its existence. (PT.)

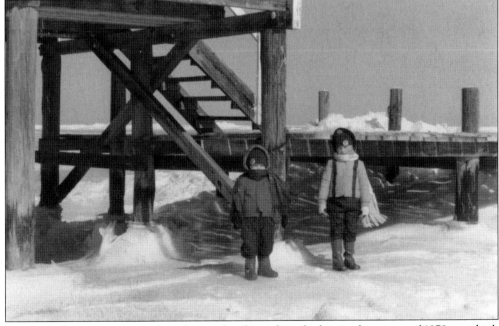

An unusual event occurred when the ice that formed on the bay in the winter of 1979 was thick enough to withstand the weight of a heavy snowstorm. Carrie Young and her brother Michael found it fun to stand on solid ice and snow where they had been swimming in the water only a few months before. (JB.)

Thirty years ago, youngsters from Holland Point, North Beach to the south, and Rose Haven to the north often gathered midway at the association building for parties. Here, in the late 1970s, "Billy Gee" presides as the Christmas party Santa Claus. A well-known performer from Chesapeake Beach Park (later called Seaside Park), Billy Gee was a longtime favorite of children. Among those attending are Norman, Jerome "Jerry," and James "Jamie" Marx; Julie, Patty, and Matt Shellin; LeeAnn and Brenda Pritt; Richard Sewell; and Steve Lanahan. (RM.)

Six

TIDES OF CHANGE
THE 1980S AND 1990S

The individuals voted into the office of president of the Holland Point Citizens Association have always given much of their own free time to pressing current issues. John Hartke, Stan Purvis, Ron Britner, Bernie Loveless, Wes Copeland, and Sheila Stout were as generous throughout the 1980s and 1990s. Some of the issues they addressed were to 1) plan and build a rock reinforcement for the deteriorating seawall and determine how to acquire the funds to accomplish this; 2) form a committee to oversee how to raise and manage association funds; 3) work toward acquiring a sewer system to replace the septic systems; and 4) take action when citizens built and improved their homes outside the realm of the local laws.

In the early 1980s, families and neighbors entertained, shared dinners, cookouts, and holidays at their homes, and enjoyed the same water activities they always had. The 1990s found grandparents entertaining their children's children at the homes they lived in, as had their parents' parents.

The 1980s and 1990s saw the reinforcement of the deteriorating seawall as well as a moratorium on building in Holland Point because of the failing septic systems. Holland Point's neighbor, Rose Haven, was faced with the dilemma of exponentially rising costs to maintain their aging sewer system. The communities, therefore, joined forces to request that the utilities and health department allow them to acquire a sewer system. An agreement was signed with the county in 1996 to entertain bids from contractors. The two communities were given a state grant for $6 million to defray building costs. By 2000, the sewer had been installed. Soon the building moratorium was lifted and residents renovated, built bigger homes on old lots, and bought and sold land on which to build new homes. Some old friends moved elsewhere. New faces appeared at association meetings, and the community readied for change.

Children living near the bay learn to crab at an early age. They also learn to pick and eat crabs as youngsters. Shown standing with crab gear on a pier in 1985 are, from left to right, Robert and Mimi Allegar, Michael and Patrick Young (with crab nets), Finley Bullard, and Carrie Young, who is confidently holding a lively Chesapeake blue crab at its back end so it cannot pinch. (JB.)

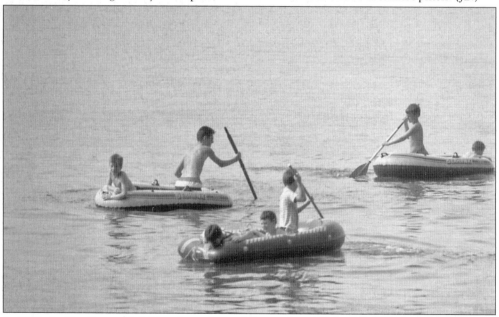

In 1988, the Breslin grandchildren have fun paddling inflatable boats in front of the family home on the bay. These inflatable boats are to newer generations what the old rubber inner tubes were to children decades ago. In those days, it was especially exciting if a child owned a truck inner tube. (JTB.)

This recipe is republished from *The Flavor of the Chesapeake Cook Book* courtesy of its author, Whitey Schmidt, who has published many books about the Chesapeake region. Restaurants in nearby North Beach, Chesapeake Beach, and Rose Haven serve up these delectable little fritters along with seafood or as a side dish. Some folks like to wash them down with cold beer. (WS.)

HOLLAND POINT HUSH PUPPIES

1/2 cup all-purpose flour
1 tablespoon light brown sugar
1/8 teaspoon salt
2 tablespoons baking powder
1/2 teaspoon baking soda
1-1/2 cups yellow cornmeal
1 egg
1 cup buttermilk
1 onion, finely chopped
Bacon drippings and peanut oil for frying

In a large bowl, combine flour, sugar, salt, baking powder, and baking soda. Mix well. Stir in cornmeal. Add egg and beat mixture with a wooden spoon until smooth. Pour in buttermilk and stir until absorbed. Stir in onion. In a deep skillet, heat bacon drippings until very hot—375 degrees on a deep-frying thermometer. Add peanut oil to a depth of 2 to 3 inches in skillet. Drop hush puppies by teaspoonfuls into oil. Fry, turning once, until golden on all sides, about 3 minutes each. Drain on paper towels. Serve warm with butter.

Serves 12.

Deep-fried hush puppies are served with fried fish throughout Bay country. The secret in this recipe is to not fry perfectly rounded teaspoonfuls of the puppies but whatever shapes they fall into when dropped into the oil.

39

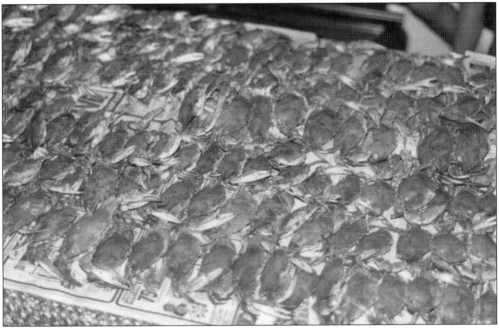

The red tide of 1981 gave residents a feast of jumbo blue crabs easily picked off of pier pilings and jetties. Heavy rains can wash chemicals into the bay, kill vital aquatic plants, cause algae overgrowth, and deplete dissolved oxygen for crabs. Though red tides can be toxic to oysters and cause fish kills, this particular one was pronounced harmless to crabs, shrimp, scallops, fish, and people. (AP.)

Bernie Loveless (1916–2004) was president of the Holland Point Citizens Association in the 1970s and again in the 1980s. He also was a longtime director. His accomplishments include heading the rock and seawall program for many years, working for the completion of the sewer connection, beautification and improvements of the community building and grounds, supervising the rock renewal, urging the renaming of North Beach Park to the more historic Holland Point, heading many oyster roast committees, and serving as both handyman and historian. He goes back a ways in these parts: as a boy, he sold newspapers in the Park and he was one of the early drivers of the new fire truck in North Beach. The HPCA clubhouse was named the Loveless Building in honor of Bernie several years before his death. (JL.)

Paul and Elvie Haas are seen fishing from their pier in the 1980s. Pier fishing has long been a popular sport, and during favorable tides, many large fish were brought up to piers without a boat ride to a deep fishing hole. Typically caught are striped bass, perch, spot, and hardhead. Occasionally a toadfish is hooked, much to the disgust of the fisherman and the amusement of bystanders. (TH.)

Paul Haas is caught playing his saxophone to the neighbors in the 1990s. He was a musician in and around the Washington area for many years. He and his wife, Elvie, were the owners of a hardware store in Washington, D.C. After retiring to Holland Point, he played at Herrington Harbor Restaurant with Sam Seymour and his band on weekends. (TH.)

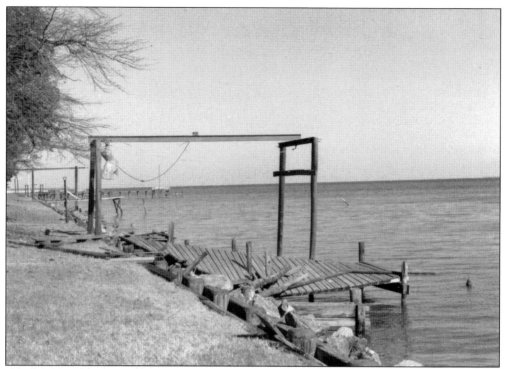

Hurricanes have everyone's undivided attention and may cause considerable damage to piers, boats, and properties. Many lesser, but still forceful, storms occur unexpectedly on the Chesapeake Bay, as happened in November 1985. The piers in this photograph exhibit some of the effects of this storm as it crashed against the seawall. (JB.)

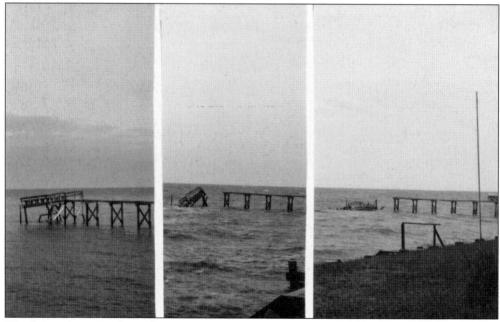

Watch as—one, two, three—the deep end of the Stacy family pier goes down, claimed by a freak storm of 1983. Much of the remains of the pier were tossed up onto the shore. (JB.)

Phil Warman sits on his pier with three of his grandchildren in 1988. The small motorboat is secured by cables to two boat lifts, which hold it safely above the deck of the pier until ready for use. After the rocks were put in to protect the seawall, and the boat hoists could no longer be used there, piers began to have lifts put on them in order to raise and lower boats. (KD.)

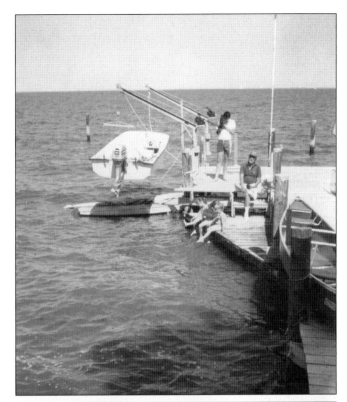

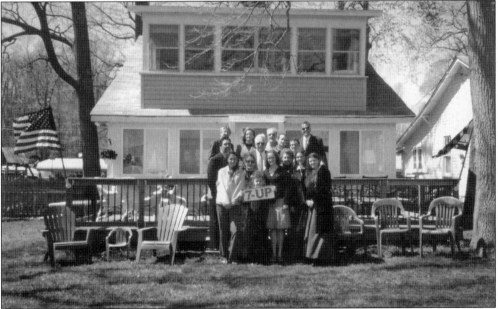

Philip Warman's family came to North Beach Park in the early 1920s. Their home was on the southern end of the bay front between Cypress and Cherry Avenues. As a founder, Phil was one of the few who remembered the old sawmill in the woods. He and his wife, Virginia, shared their cottage, called 7-UP, with children and grandchildren. They gather here in 2006 for a memorial after Phil's death at the age of 90. (KD.)

The *Queen Elizabeth II*, on her maiden Chesapeake Bay voyage, passed directly in front of Holland Point on Sunday, May 5, 1985, at about 10:00 a.m. The great ocean liner is shown heading south to the Atlantic, returning from the port of Baltimore. Watching cruise ships, freight carriers, and fishing and recreational boats is a favorite pastime of residents living or strolling on the bay front. (JB.)

In the 1980s, the pilot of this seaplane made an emergency landing in the bay near Linden Avenue after the plane had blown a gasket. He walked in the shallow water to a pier. Raymond Young, on the left, then used his small whaler to tow the plane to Rose Haven marina for repair. Boats often end up being towed to shore after running out of gas or hitting a commercial crab net. (NY.)

The Holland Point Christmas Party is an annual event for residents and their families. From left to right stand (first row) Lindsay Power and Christina, Jason, and Dorothy Loveless; (second row) Sue Power and Jay and Betty Loveless at the 1990 party. Sue Power has been a tireless worker for the association. In addition to helping at the Christmas parties, she was in charge of the oyster roast for many years—a major job. (SP.)

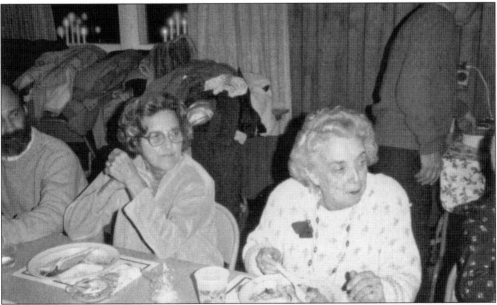

At the 1988 Christmas party, two longtime residents of Holland Point sit together: Jane Tepper with Virginia Casey (on the right). Leon and Jane Tepper had a house at Beach Avenue, now the southernmost street of Holland Point. For many years, the association was able to count on Jane and Leon to bring a large number of people with them to the annual fund-raising oyster roasts. (VC.)

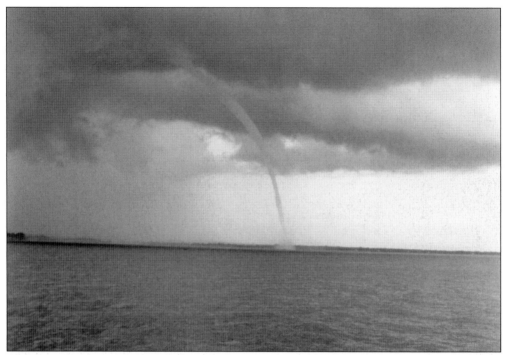

Waterspouts are seen often on the bay, but this one was one of the largest witnessed and recorded. Sue and Jack Power captured it on film in April 1982 off the point in Holland Point. Such waterspouts can be quite dangerous to boaters and are best avoided if possible. (SP.)

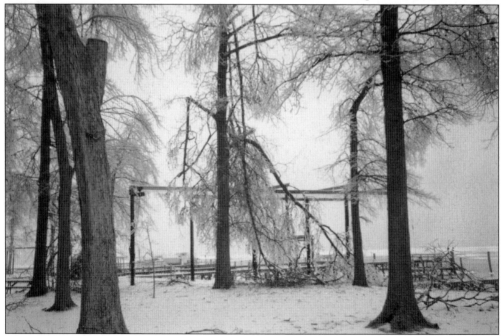

Branches, limbs, and trees blocked the roadways, brought down the power and phone lines, and fell on homes during this ice storm in 1994. The heavy ice weighed down the power lines and coated the branches of the trees, as seen in this photograph. (RM.)

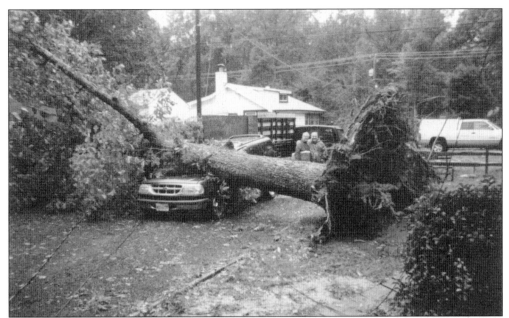

In September 1999, one of Hurricane Floyd's damages was to send a giant 100-year-old oak crashing down on this Ford Explorer as well as another car. Their owners, Raymond Potvin (left) and Raymond Young, survey the total damage to Nancy Young's vehicle. With over 10 inches of rain pooled on the saturated ground, the roots of many old trees lost their grip on the earth. (JB.)

The late winter ice storm of 1994 left some in Holland Point without electricity for 5–14 days. Candles, oil lamps, battery lights, kerosene heaters, wood fires, and canned food—these all began to lose their novelty after a few days. Residents were left with a greater appreciation for today's modern conveniences. (SS.)

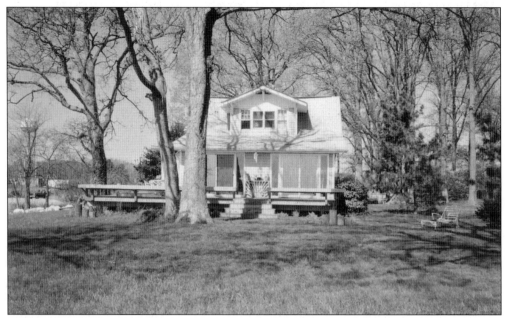

Herman Burgess bought five lots at the south end of North Beach Park between Ash and Beach Avenues in 1922. Until the 1950s, he ran a small marina to the south of his property, one of the only two existing commercial establishments permitted by the community's founder. Ash Avenue was wiped out by storms over the years, and today the only access to the property is from Beach Avenue, but a rock wall protects the southern embankment. By 1999, the home, as pictured above, had been owned by several others and then was purchased by James Deakins. He had it demolished in the early 21st century, when the moratorium on new construction was lifted, and built the luxury home shown below. (Above SS; below PH.)

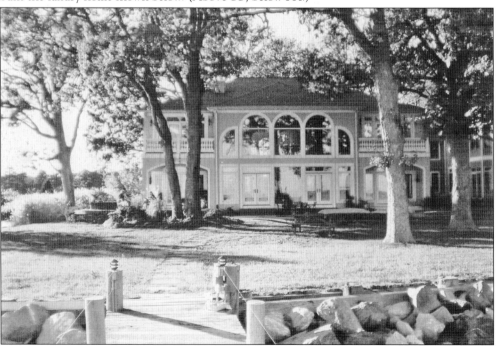

No double wedding on the Chesapeake Bay is complete without a tiki bar such as this one, constructed in 1999 by, from left to right, Jamie Marx, Norman Marx, Carl Raulin, and a friend the morning before the wedding. This would be the focal point of the reception that was held after the minister completed the waterfront ceremony. The beaming bridegrooms are brothers Jamie and Norman. (RM.)

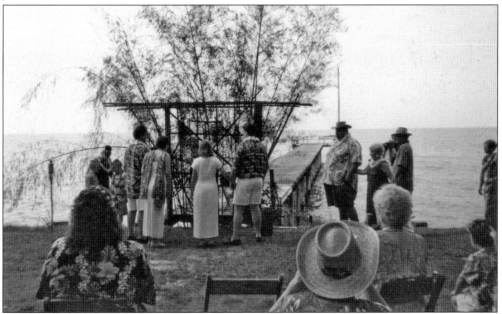

Guests witnessed the double wedding on July 24, 1999, of Norman and Jamie Marx to their brides, Michelle Hatcherson and Dawn Blair. Rev. Gary Fruik married the couples right at the top of the shared pier in front of Ruth Marx's home. After the ceremony by the bay, the wedding party and guests simply turned around to enjoy the tiki bar and Caribbean-themed reception. (RM.)

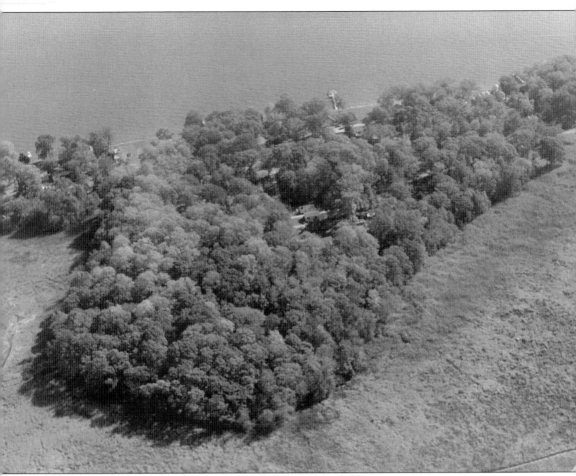

An eagle's-eye-view photograph taken by Joy Baker in the 1990s off the end of Cedar Avenue shows the Chesapeake Bay bordering Holland Point to the east and the marsh bordering it to the south and southwest. At center is Cedar Avenue, one of the very few platted inland streets ever to be developed in the 20th century. Tracks from all-terrain vehicles visible in the marsh are clear signs that muskrat trappers and joy riders have entered the marsh during an autumn dry season. West of Walnut Avenue, residents appreciate the unique natural life and the fragility of the protected wetlands, which do their vital job of absorbing tides and big rains. They also have a private bird sanctuary. (JEB.)

Over the past decade, Chesapeake Bay shores have seen the gradual return of our national bird, the bald eagle. Holland Point is no exception. This photograph silhouettes a weathervane mounted on a piling at the end of the McKenna family pier. The eagle on the top could easily be mistaken as part of the weather vane itself, but, in fact, this live bald eagle has just landed there. (DM.)

Sue and Jack Power were astonished to find this river otter enjoying the pier in front of their home. The otter, *Lutra canadenis*, is a secretive but playful member of the weasel family with dense brown fur and silvery undersides. It is usually highly aquatic but also frequents the wooded riparian areas of the Chesapeake. (SP.)

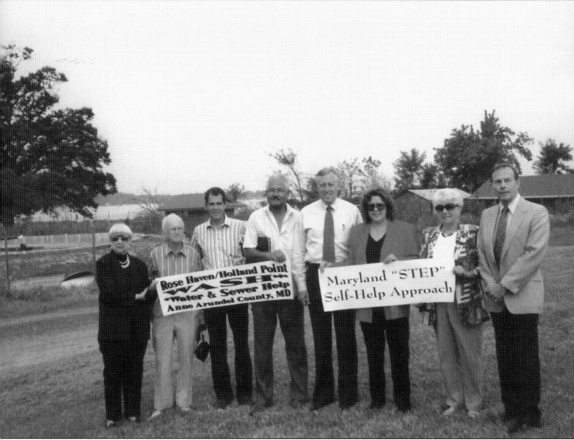

The WASH (Water and Sewer Help) team from Holland Point and nearby Rose Haven explored many options during the 1990s to fund a shared sewer system to replace Rose Haven's ailing one and the many failing private septic fields in Holland Point, which were declared dangerous for the bay. Marking the project's kickoff, from left to right, are members EvaDean Lint, Bernie Loveless, Delegate George Owings, Wes Copeland, Congressman Steny Hoyer, Vivian Trawick, Sheila Stout, and Tom Gill. Their efforts were rewarded when Representative Hoyer and U. S. senator Barbara Milkuski helped to obtain a $6-million federal grant to offset half of the private costs of the project. Planning, contracting, and construction of the complex system that diverted effluents to a Chesapeake Beach treatment plant took many more years. When it was completed, the moratorium on building was lifted, and many residents began expanding their homes and building on lots. (SS.)

Seven

MODERN TIMES

THE 21ST CENTURY

As president in 2000, Ed Pachico continued to handle issues with the new sewer. After its installation, residents could again obtain building permits. New and larger homes quickly replaced small cottages and empty lots, resulting in rising property values. In 2002, Steuart Chaney of Rose Haven offered association president Ed Conaway a plan to purchase 136 acres of land within Holland Point long owned by Sceno Investments. The consummated deal with Chaney includes his donation of several lots near the association building and a payment to Holland Point Citizens Association. Most importantly, Chaney promised to preserve more than 100 acres of wetlands and woodlands in this parcel. His company would build only 20 new homes, as opposed to the Sceno developer's plan to build hundreds. Residents felt that such controlled development assured the Park's survival.

Judy Harger became president in 2006. She is focusing on completing the installation of a handicapped ramp for the Loveless Building and constructing a Web site.

Natural disasters are a continuing challenge in waterfront life. During Hurricane Isabel in 2003, some residents evacuated and returned to find huge pier wreckage on the shoreline. Others navigated the flooded roads with their kayaks to get to North Beach for supplies, as people did after the hurricane of 1933. No one from Holland Point lost home, life, or limb as a result of Isabel's water surge, but it did destroy several houses and the boardwalk in North Beach.

Hurricanes as well as other aspects of nature in this fragile area have long been an integral part of its history. What originally drew Native American tribes, English settlers, farmers, and watermen still draws people to visit and move here. In addition to people, other intruders migrated, one way or another, to this location. Plants, mammals, birds, and aquatic creatures such as phragmites, nutria, mute swans, and mitten crabs have all invaded the land at one time or another. This is part of the challenge and fascination of living close to nature. The Chesapeake Bay and the land that surrounded it originally were virtual cornucopias of food and resources. Even though the bay's resources have been diminished greatly, people are still drawn to it today to fish, swim, boat, play, and live. Holland Point is not just another suburban community. It is surrounded by, and partakes of, the everyday life of the changing bay and marshland.

Bernie and Dorothy Loveless spent a beautiful day at their last annual oyster roast together in October 2000. They moved to the community in 1970, but Bernie knew it as a boy when his family lived in nearby Owings. They both served as Holland Point Citizens Association officers over three decades, Dorothy being a particularly meticulous secretary. Bernie was the man in charge of "the rocks" and became the honoree of the Loveless Building. (JB.)

Joy Baker stops by the "white elephant sale" table staffed by Jean Morris and her mother Janet Bates at the 2006 Holland Point oyster roast. This annual mini flea market provides for the recycling of small household items and jewelry donated by residents and adds to the Holland Point Citizens Association treasury. It is popular with the children, who discover treasures marked down to almost nothing at the end of the afternoon. (JP.)

This close-up of a succulent plate of freshly shucked local raw oysters was snapped at the 2006 Holland Point oyster and bull roast. They are still served up raw, roasted, and steamed, but the traditional deep-fried offering at these events has passed into history. (KP.)

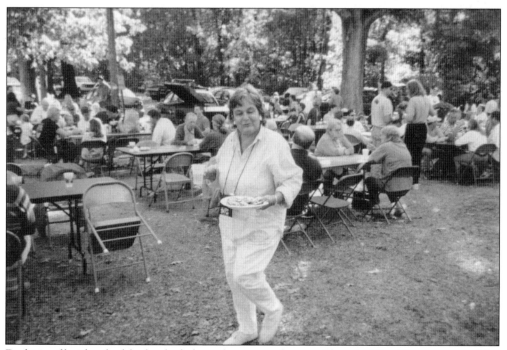

Dashing off with a freshly shucked plate of oysters and a cup of beer is Alice Birney at one of the annual oyster roasts. It was another fine day under the trees as the community and guests gathered at shared tables to dine, play at games of chance, and buy plants and home-baked sweets. (JB.)

This picture of Ronald and Anna Britner was taken in 2005 at their 50th anniversary. Their home was north of the Point on Herring Bay at Catalpa Avenue. Both were very active in the association's activities. Ron was president for several years beginning in 1975. Anna, with Sue Power, was cochair of the annual oyster roast for many years. (RB.)

Wesley Copeland was president of the association for several terms until 1996. He first came to the community in 1986 as a weekender with his wife, Char, a graphic artist. In 1978, Copeland founded the International Science and Technology Institute, a Washington, D.C.–based company that provided economic, social, and scientific consulting services for U.S. Agency for International Development (USAID) to developing countries. In 1995, he retired to live full-time in Holland Point. (JH.)

Sheila Stout was president of the Holland Point Citizens Association from 1996 to 2000. She convinced Anne Arundel County to truck away the massive amounts of debris gathered by residents after Tropical Storm Fran hit the community hard. She also was very active on the new public sewer system team and served as liaison during construction. Sheila purchased her home in Holland Point in 1987. She retired in 1992 after 30 years of teaching in Montgomery County. (SS.)

Ed Conaway purchased his Holland Point home in 2000 and served as president of the association from 2002 to 2006. He is also president and owner of All American Environmental Services, Inc. He negotiated a complex agreement with the landowner of a large group of wooded lots slated for development, resulting in the preservation of woodlands and wetlands in the environmentally sensitive community. (EC.)

Here are the shrimp feast servers, working a volunteer shift in the spring of 2007. From left to right are Carol Wyman, Margaret (Peg) McKenna, Katherine (Kathy) Young, and Katherine (Kathy) Conaway. Hot dogs and hamburgers with all the trimmings are offered in addition to steamed shrimp. (JP.)

Douglas Sisk in 2007 smiles over the wheel of fortune, a popular game of chance. It makes an appearance as a fund-raiser at the annual autumn oyster roasts and the relatively new spring shrimp feasts. Doug and his wife, Terri, are both active volunteers at community events. (JP.)

At the Shrimp and Azalea Festival of spring 2005, Holland Point's roulette man, Jack Power, encourages former association president Ed Pachico to place a bet. The wheel is a featured activity at oyster and shrimp fests. Volunteers help make these events successful money-makers for Holland Point Citizens Association while they enjoy socializing with neighbors. (SS.)

Judy Harger assumed the presidency of the Holland Point Citizens Association in 2006 for a two-year term. She moved to Holland Point in 1999 after retiring as a U.S. Army colonel. Her military career in the army Nurse Corps included service in combat fields. Currently she does clinical research in nursing when she is not leading association meetings or scuba diving. (JH.)

From left to right, Nancy Young, sister-in-law Kathy Young, and neighbor Ruth Marx share a last drink together after boarding up home-fronts in preparation for Hurricane Isabel in September 2003. It had been 70 years since the last disastrous storm had occurred. (NY.)

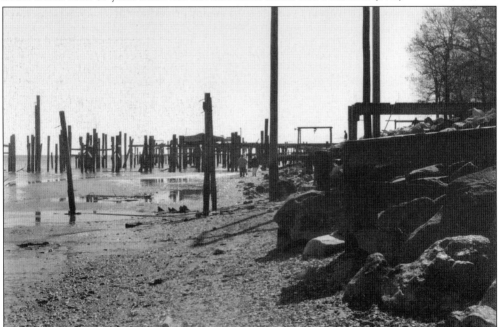

Many of the residents fled just before the tidal surge of Isabel's wrath flooded the road on September 19, 2003. The houses were all spared, but the massive damage done to the piers became picturesque only during a low tide many weeks after the storm. Planks were ripped from pier pilings and tossed about. The old beach returned for this odd day two months later as "Stonehenge-by-the-Bay." (KY.)

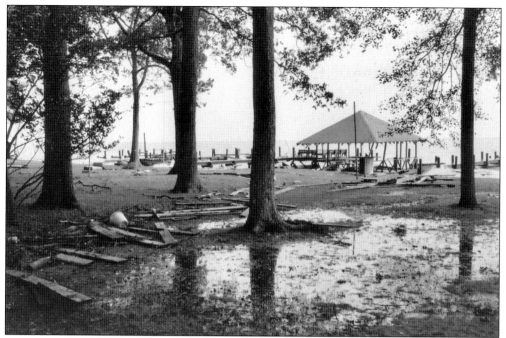

This unique pier pavilion was built in the early days when Officer Bill Clark owned it. Surviving many hurricanes, it succumbed to Isabel in 2003 after Ralph and Jane Carrello had owned it for 15 years. A water surge flooded the grassy promenade and demolished the supports for the pavilion, shown after the storm about to collapse. Community rules prevent rebuilding a destroyed structure on the common ground. (KY.)

Kayaks replaced cars for travel in and to the town of North Beach just after Hurricane Isabel in September 2003. Since the road from Holland Point also was flooded in parts, those residents remaining or returning made practical use of their recreational boats for shopping runs and event photography, just as they did after the great storm of 1933. (BB.)

The bay front of Holland Point remains a popular setting for family gatherings and parties. Here four generations of the related Bates, Morris, Young, Newman, and Schwab families and the extended family of Hohnadels and Walkers gather in July 2005 to celebrate the 80th birthday of Janet Bates, front left. (JM.)

Gathered at Kathy and Woody Young's home to toast the 2007 Kentucky Derby are, from left to right, Kathy Young, Jean Pulse, Janet Bates, and Nancy Young, each wearing a lucky Derby hat. In the next room, the husbands are watching the actual derby on television. (JP.)

On September 24, 2004, Debbie Powell became the bride of Philip Ashworth in a Holland Point bayside wedding held in front of the David McKenna home. Pictured from left to right are (first row) Brianna Powell, Madeline Ashworth, and Brianna's twin sister Deanna; (second row) Sara Grove, Lisa Cohen (partially obscured), the bride, Margaret Ashworth, and Noel Brightwell. (DM.)

In the summer of 2006, Peter Hooper and Nancy Sullivan were married at an outdoor ceremony in front of their new home on the day Peter bought it from Jim Deakins as a wedding present for his bride. Beside it can be seen another large house belonging to the Jack Bannister family. These homes are built on part of the original five lots purchased by Herman Burgess in the early 1920s. (PH.)

On April 27, 2005, Steuart Chaney presented a $20,000 check to HPCA officers and directors. Shown at the event from left to right are Bob Tait, Sheila Stout, Woody Young, Jack Bannister, Pres. Ed Conaway, Steuart Chaney, Doug Sisk, and Hamilton Chaney. The result of years of negotiation, this first payment marked the purchase of 136 acres of Holland Point land by Chaney and his company from Sceno Development Company. Sceno had been the major landowner since the 1940s and planned to build hundreds of new homes on the fragile land. Instead, Rose Haven neighbor and community benefactor Chaney agreed to put 103 acres into conservation preservation and construct only 20 homes southwest of Walnut Avenue. The Holland Point Citizens Association also received the deed to the lots behind the association building in exchange for transferring to Chaney the rights-of-way on his building tract. (EC.)